COLLINS • Learn to pa

D0478063

Oils for the Beginner

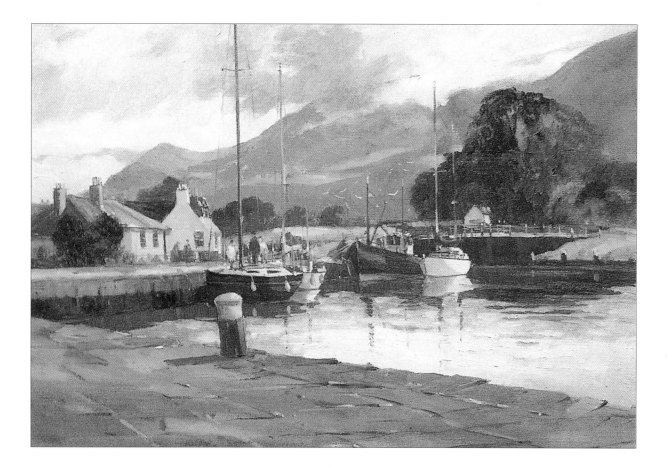

ALWYN CRAWSHAW

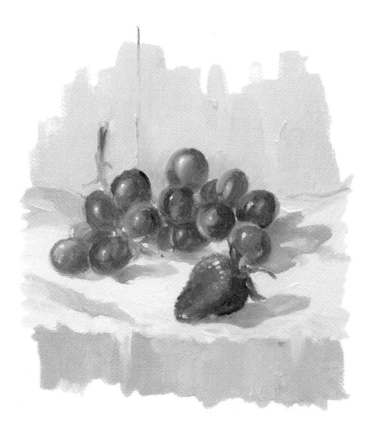

First published in 1987
by William Collins Sons & Co Ltd, London
Reprinted 1989, 1990

Reprinted by HarperCollins*Publishers* 1991, 1992, 1993,
1994, 1995, 1996, 1998 (twice)

© Alwyn Crawshaw 1987

Alwyn Crawshaw asserts the moral right to be
identified as the author of this work

Photography by Nigel Cheffers-Heard

**A catalogue record for this book is available from
the British Library**

ISBN 0 00 413344 7

Printed in Hong Kong by Sing Cheong Printing Co. Ltd.

CONTENTS

PORTRAIT OF AN ARTIST
ALWYN CRAWSHAW

Fig. 1 Alwyn Crawshaw

Successful painter, author and teacher, Alwyn Crawshaw was born at Mirfield, Yorkshire and studied at Hastings School of Art. He now lives in Dawlish, Devon with his wife June where they have opened their own gallery. Alwyn is a member of the Society of Equestrian Artists and the British Watercolour Society, a Fellow of the Royal Society of Artists, and is listed in the current edition of *Who's Who in Art*. His work has brought him recognition as one of the leading authorities in his field.

As well as painting in oils, Alwyn also works in watercolours, acrylics and pastels. He chooses to paint landscapes, seascapes, buildings and anything else that inspires him. Heavy working horses and elm trees are frequently featured in his paintings and may be considered the artist's trademark.

This book is one of eight titles written by Alwyn Crawshaw for the HarperCollins *Learn to Paint* series. Alwyn's other books for HarperCollins include: *The Artist at Work* (an autobiography of his painting career), *Sketching with Alwyn Crawshaw, The Half-Hour Painter, Alwyn Crawshaw's Watercolour Painting Course* and *Alwyn Crawshaw's Oil Painting Course.*

Alwyn's best-selling book *A Brush with Art* accompanied his first 12-part Channel Four television series. A second book, *Crawshaw Paints on Holiday,* accompanied his second 6-part Channel Four series, and *Crawshaw Paints Oils*, is the third Channel Four television series with a tie-in book of the same title. In addition, Alwyn has been a guest on local and national radio programmes, and has appeared on various television programmes. Alwyn has made several successful videos on painting and in 1991 was listed as one of the top ten artist video teachers in America. He is also a regular contributor to *Leisure Painter* magazine. Alwyn organises his own successful and very popular painting courses and holidays as well as giving demonstrations and lectures to art groups and societies throughout Britain.

Fine art prints of Alwyn's well-known paintings are in demand worldwide. His paintings are sold in British

and overseas galleries and can be found in private collections throughout the world. Painted mainly from nature and still life, Alwyn's work has been favourably reviewed by the critics. *The Telegraph Weekend Magazine* reported him to be 'a landscape painter of considerable expertise' and *The Artist's and Illustrator's Magazine* described him as 'outspoken about the importance of maintaining traditional values in the teaching of art'.

Alwyn believes that if artists first master the rules of their craft and learn how to paint in a realistic style, they can then develop from that point.

Fig. 2 Penny for your Thoughts

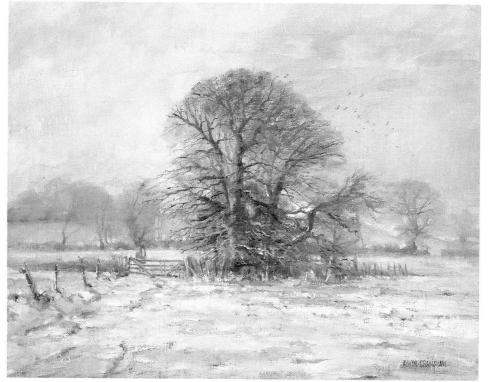

Fig. 3 Snow, Metcombe

THE EXCITEMENT OF PAINTING

Fig. 4 Painting indoors

Fig. 5 Painting outdoors

I wonder what it is that makes us want to paint? Before the camera was invented painting was the only way of communicating visually with others, therefore not only were painting and drawing important, but to a great extent they were necessary. But, even with the camera and its modern technology, there seem to be more people painting now than ever before. If we stop to think, this urge to paint has been with us for a long time. Over twenty-five thousand years ago our ancestors painted on their cave walls but no-one knows exactly why they painted. It could have been for the instruction and education of their children, for decorating their caves, or even as a creative pastime.

With all the problems those cavemen artists had to face, I feel that they must have been very dedicated to their art if they worked simply for a pleasurable pastime. They would have had to find the raw materials from which to make their paints and 'brushes', and then sit down and manufacture them. The working-time would have been restricted to bright daylight hours, near the cave entrance, or, if deeper inside the cave, they would have had to work by firelight. I like to think I am a hard-working, dedicated artist, but when I consider my ancestors, working in the caves, they had the edge on me!

I believe the reason why people want to paint is simply that we all, or nearly all, have a creative urge inside us and painting is one exciting way of fulfilling that urge.

Painting has no social boundaries. Indeed, royalty have painted in the past and so do members of the Royal Family today. There is no age limit set on painting. In fact we all started when we were just capable of holding a pencil. We then progressed to a brush and paintbox, and most of us hadn't even started school! At the other end of the scale some people don't start painting again until they retire, and I have taught some students who 'got the creative urge to paint' at eighty years of age.

There is no restriction as to when you paint. You can choose to paint indoors in the winter if the day is miserable and wet, and outdoors in the spring, summer and autumn, or very simply, whatever the season, if the weather is good and you feel like a day in the fresh air, then work outside. You can work for half-an-hour on a small sketch or take weeks to finish a large oil painting. The choice is yours. You will find the excitement doesn't only come from the actual painting of a picture, but also from the preparation and planning of your painting. If you decide to have a day out looking for a subject, the anticipation, while you are preparing your equipment and waiting for the day, can be very exciting. When I have had commissions to do that have entailed pre-planning and working a day or two away from home, the excitement of the preparation and build-up to the great day have only been surpassed by being there and actually working on the painting.

There are local art societies that you can join where you will meet and mix with kindred spirits. You will

Fig. 6 Summer in Devon, painted on the spot outdoors

find people who are all in the same boat as you and are keen to learn from you and give you their advice and practical knowledge in return.

If you are a real beginner, and haven't previously painted in any medium, then you might be rather worried about starting to paint. 'After all, only artists can paint and I am not an artist.' I have heard this said many times. Well, of course if you aren't an artist you cannot paint. You wouldn't be expected to drive a car if you hadn't learned to drive one and, in the same way that you can learn to drive a car, you can learn to paint. Naturally some students will be far better than others, but it doesn't matter what standard your work is (naturally, the more you practise, the better you will get). The important factor is that your own thoughts and skills will have been used to create something that is absolutely unique to *you*. I can't start to explain what a tremendous feeling of satisfaction you will get from looking at your first finished painting.

Before you start to paint, there are two important things I would like to say. First, when we are confronted with a subject that is totally new to us, there is an air of mystery about the subject. This is natural, because we have no idea of 'how it works' or 'how to do it'. Well, at this moment there must be a mystery about painting for you. Don't be worried by this; I will lead you through the book, taking you stage by stage in a logical order from the very basic steps to more adventurous work. You will find from starting the very first exercise that the mystery will slowly disappear

and you will be totally involved with a new pastime, hobby or even eventually a profession that holds enough interest and creative variation to last your whole lifetime, whether you are eight or eighty years old.

Second, it is said that you need to be born with a natural talent to paint. I agree it is obviously easier for a person who has natural talent to climb the ladder of success (although not without hard work), but I believe also that just as important as natural talent is 'the will to paint'. Even a person who is a 'natural' will not progress very far if he has no will to paint. So the limits of your painting progress are up to you, but remember you must practise and, above all, enjoy your painting.

Finally, because you are reading this book, whether you have painted before in other mediums and wish to try oil paint, or you are a beginner to painting and have chosen oil as your medium, you have taken your first big step. If you are a beginner then you are curious and your creative instinct has been aroused. If you have painted before in other mediums, your desire to express yourself differently in a new medium has been stimulated. In either case, can I suggest that you relax and read through the book before you start to paint, then you will feel familiar with the colours, materials and exercises on which you will be working. Then start with the first exercises. If you feel that one is a little difficult for you, go on to the next exercise and then come back with a fresh eye and tackle it again.

WHY USE OIL PAINTS AND WHAT ARE THEY?

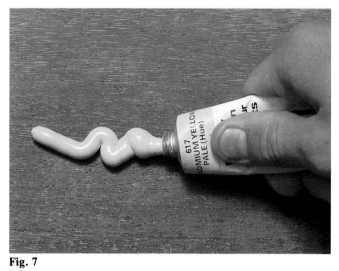

Fig. 7

I think two of the most difficult questions I am asked are: which medium do I prefer to use, and which season do I prefer to paint – winter, spring, summer or autumn? The answer to both questions is very similar. When I am, say, working in watercolour, I get so involved that I can't believe I would be as happy working in another medium. But then I put the watercolours to one side and work, say, in oil, and within a short time I have forgotten all the pleasure that watercolour gave me and I feel so involved with oil that I am convinced it is the only medium that can cope with my painting creativity – until I work with another medium, and so on.

It is the same with the seasons of the year. When I am painting in summer I enjoy it so much that I can't believe the winter will give me the same inspiration; but when winter comes I forget all the other seasons and enjoy it as though there were no other times to paint. I suppose what I am trying to say is that whatever I am doing at the time, I try to enjoy it to the full.

You have chosen to paint in oil. If you are a beginner, perhaps you have chosen oil painting because it is very traditional. You may have been to some of the public galleries and found the majority of pictures are oil paintings, so you are inspired to paint in the same way; or it could be that you have been given a set of oil paints as a present; but whatever the reason, you have been inspired to have a go.

There is one other very obvious reason for choosing any medium in which to work, and that is the single fact that you like it, either because of the way you have to work it or the look of the end result. If you find

after working with oil paint (giving yourself plenty of time to practise and find out) that you cannot get on with it, then perhaps this medium isn't for you. Don't despair – there are many others with which to work.

First, let us take a closer look at oil painting. We all have a 'natural painting size' that we like to work, or we find more comfortable when working. Some artists work very small, say 13 × 7 cm (5 × 3 in), and others very large, up to 152 × 102 cm (60 × 40 in) or bigger. This is one of the beauties of oil painting – there is no restriction on size, except for space to paint and your bank account if you work very large! My natural size for a landscape is 51 × 76 cm (20 × 30 in). I don't paint many larger, and the largest I have painted is 152 × 76 cm (60 × 30 in). I find 18 × 13 cm (7 × 5 in), 25.4 × 20 cm (10 × 8 in) and 25.4 × 30 cm (10 × 12 in) ideal sizes for sketching outdoors.

For the exercises in this book, I have purposely kept the sizes small. I think this is very important for a beginner. The reason is simple: if a picture for an exercise were too large, say 51 × 76 cm (20 × 30 in), then you could become bored or even disenchanted, as to you nothing would appear to be happening with the picture because there was too much canvas to cover and work on. The spreading of the paint and handling of the brushes, and even the mixing of colours, will be done more easily and more confidently on a smaller scale. If you feel strongly about painting large canvases, however, please don't let me stop you; after you have gained some experience you will recognize your 'natural working size' and will feel very comfortable when you are painting.

When I was sixteen years old and at art school, I was asked by the owner of a local 'olde worlde' gift shop in Battle (the town where I lived and where King Harold lost his eye at the Battle of Hastings in 1066) if I could draw and paint a monk, life-size on board, to stand outside the shop as an attraction. I was very flattered, especially as I was to be paid for the work what was in those days a lot of money for a young art-school lad. The one thing my sixteen years of experience in this world had not encountered was a large painting, so of course there were no danger signals. I accepted my first large painting commission very gratefully and with tremendous enthusiasm.

It wasn't long before the enthusiasm turned to despair as I laboured hour after hour working on a board much taller than myself! The areas to cover in paint seemed as large as oceans and my wrist ached with the movement of the brush strokes. I think I can remember

enlisting the help of my twin sister Shirley, who was also at Art School, to help me finish it, and another brush was very welcome. But that, of course, is how one builds up experience and confidence. I was a better artist for doing it. I also learned that very large paintings were not my 'natural working size'!

Colours

Now let us look at the materials with which we are going to work. Oil paint is pigment ground in oil and it is the oil that sticks the paint to the canvas or paper. This explanation is over-simplified, but it serves our purpose as painters. Oil paint is bought in tubes (**fig. 7**) and is squeezed out onto a palette for working. Then, with a brush, we add a medium to the paint which helps to thin it down or make it move (spread) more easily over the canvas. You can get mediums with an additive for speeding up the drying of the paint. Finally, there is another medium for washing our brushes out. More about all this a little later.

Some pigments when ground with oil harden very quickly, and used to go hard in the paint tube, while others take a long time to dry. For instance, Ivory Black dries much more slowly than other colours, therefore if you drew your picture with your brush, or underpainted, using Ivory Black, when other colours were painted over the top, and these dried, they would crack. I don't use black for any of my painting, in whatever medium I am working. I prefer to mix a dark colour (black) from the three primary colours, red, yellow and blue, because I feel it produces a more lively colour. If you decide at a later stage to use black, I suggest you don't get Ivory Black because of its slow drying time. Apart from Ivory Black, the drying time and early hardening of paint in the tube has been rectified by the artists' colourmen (the manufacturers), and when you buy your tubes of paint you will find that the drying time and working life of all these paints will, with some slight variations, behave in the same manner. I have some tubes of colour many years old and they are still usable.

There are two qualities of colours: artists' professional quality and students' colours. Artists' quality are expensive, but you will find students' colours perfectly adequate. I have used Georgian oil colours (a students' quality) for all the exercises in this book, and I would not hesitate in recommending that you use them. The colours that I use for all my oil painting, including those used throughout this book, are shown in **fig. 8** in the position I place them on my palette. This is *very* important; you must always put your colours on your palette in the same position every time you paint, to enable you to reach your brush into a particular paint without even thinking about it, so that it becomes second nature. Also illustrated in **fig. 8**, to the right of the palette, are five other colours you can try later on when you have gained experience.

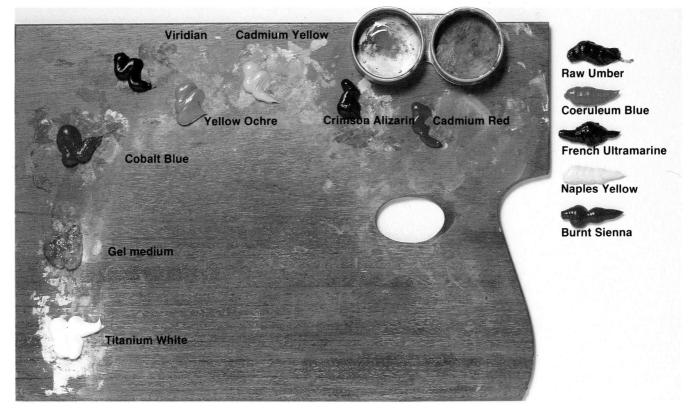

Fig. 8 Oil colours set out on the palette

WHAT EQUIPMENT DO YOU NEED?

Brushes

The brush is the most important item of your equipment. It is the brush that makes the marks on the canvas that eventually join together and create your picture. Always buy good quality brushes, as a good brush (if looked after) will last you for hundreds of painting hours. I have brushes that I have used for many years. In fact, you will find that a brush will get better as you use it, and as time goes on it will become a very familiar part of your painting life, and you will become very fond of it.

The choice of brush is very personal. To help you decide what you need to start with, I have listed on page 14 the brushes I used for the exercises in this book. **Fig. 9** is a photograph of brushes used in oil painting; they are actual size. Naturally, different shapes of bristles give you different marks. There are three basic shapes of brushes: round, filbert, and flat. I prefer the flat brush, but I use a small round sable or nylon brush for detail work. Series of brushes for oil colours start at No. 1 (the smallest) and continue up to No. 12, in most series, the largest.

Keep your brushes clean by washing them in turpentine substitute (white spirit) and then wash with soap. Put some soap on the palm of your hand and rub the brush into it, doing this under running cold water. Make sure you rinse out the soap, and of course the brushes must be dry before you use them again. During normal working keep your brushes in turpentine substitute to stop them from drying out. When you pick up a brush for use, wipe it on a piece of rag to remove the turps.

Palette Knives, Painting Knives

Palette knives are often used for mixing up paint on your palette, but, unless it is a *large* quantity I want mixed, I mix paint with my brush. However, mixing a large quantity with the brush can get the bristles too full of paint. If this happens, carefully squash the brush bristles on the palette with a palette knife to squeeze the excess paint back on the palette. This knife is also used to clean paint off the palette. A palette knife is illustrated in **fig. 10**. Three painting knives are also illustrated on the same page. The difference between palette and painting knives is that the painting knife has a cranked handle to allow you to apply paint onto the canvas when painting a

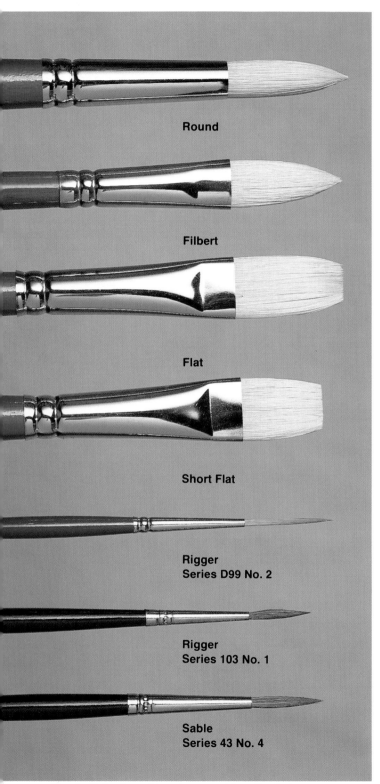

Round

Filbert

Flat

Short Flat

Rigger
Series D99 No. 2

Rigger
Series 103 No. 1

Sable
Series 43 No. 4

Fig. 9 Selection of brushes used for oil painting

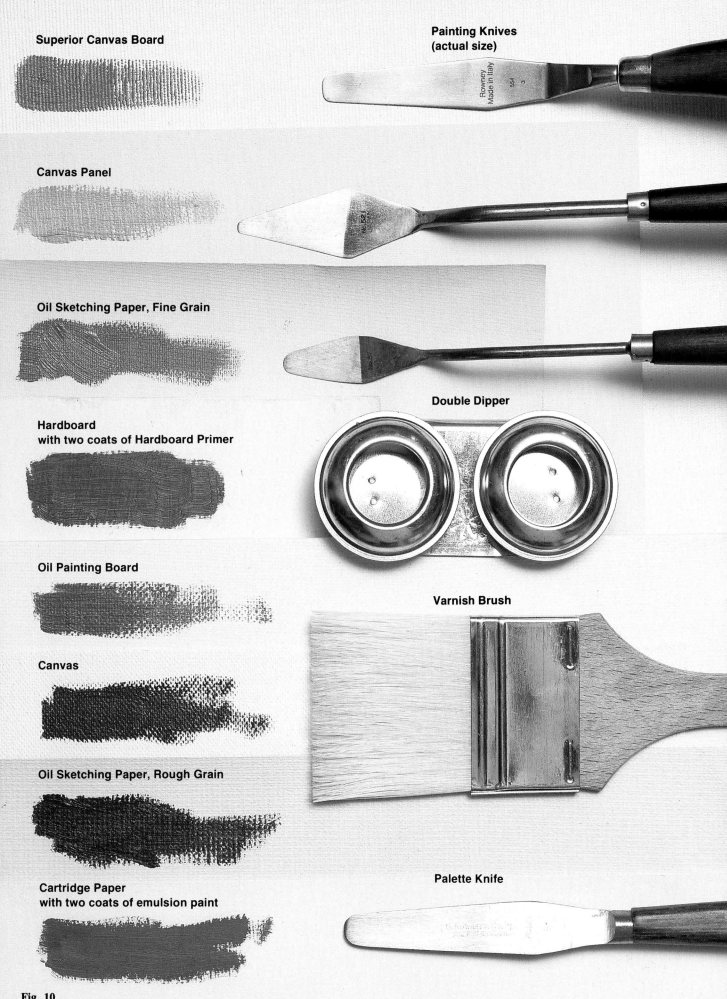

Superior Canvas Board

**Painting Knives
(actual size)**

Canvas Panel

Oil Sketching Paper, Fine Grain

Double Dipper

**Hardboard
with two coats of Hardboard Primer**

Oil Painting Board

Varnish Brush

Canvas

Oil Sketching Paper, Rough Grain

**Cartridge Paper
with two coats of emulsion paint**

Palette Knife

Fig. 10

palette knife picture, and the blade is more delicate. There are many shapes and sizes to choose from and, as with brushes, the choice is personal. However, I have suggested which ones to use in the section on palette knife painting on page 33.

Painting Surfaces

The traditional surface (support) for oil painting is canvas. It is usually bought already primed and stretched. This means that four stretcher pieces have been slotted together to form a frame and the canvas has been professionally stretched over and fastened onto the frame. Two wedges are put into each corner of the frame. When these are knocked in with a small hammer, the canvas tension increases as the frame gets slightly larger, until the canvas is 'drum' tight. Then it is ready to paint on. Canvas can be bought by the metre (yard) length and then stretched at home. However, I don't recommend this if you are a beginner.

Fig. 10 shows different painting supports reproduced actual size. Canvas is the most expensive. However, there are many more less expensive surfaces to work on, but take note: all absorbent surfaces should be primed, or the oil will be sucked into the surface, leaving behind the pigment laying on the top with no adhesion, which could then be 'brushed' off. Most supports are already primed for working on when you buy them. The most common one that is not primed is hardboard. This is a very popular oil painting surface and usually it is the smooth side that is used for painting. Incidentally, use indoor quality not exterior board, as the latter has been treated and could cause problems with the oil pigments.

To prime the board simply means to seal the surface and at the same time allow the paint to be easily applied. There is a product on the market specially made for priming hardboard; this is called Hardboard Primer. It has a special resin which produces a hard and durable surface. It dries in less than three hours, and I would suggest giving your hardboard two or three coats for the best results. You can also prime hardboard with two coats of emulsion paint or house-hold undercoat paint. If a non-water-based paint is used as primer, it is better to seal the surface first with a size which you can buy from a hardware shop.

If you want to work on a large piece of hardboard, say over 41 × 51 cm (16 × 20 in), it is best to glue some wooden battens on the back to stop it from warping. Hardboard has one disadvantage: it doesn't have a grain to the surface (tooth). It is smooth and some students at first find it a little difficult to paint on although, when you get used to it, hardboard is an excellent surface on which to work. The other side has a very rough mechanical-looking grain and is not recommended; it also takes a lot of paint to cover the surface. If you have any difficulties with the smooth surfaces, or you don't want to prime, there are plenty of ready-primed canvas or canvas boards on the market. The sizes range from about 18 × 13 cm (7 × 5 in) up to 91 × 61 cm (36 × 24 in). They have different surfaces and are excellent to work on. There is also oil painting paper which is ready primed and can be bought in pads as well as sheets. I started my oil painting using oil painting paper when I was at Art School.

Mediums

As I said earlier, a medium is added to the brush to help thin the paint or help it move (spread) over the painting surface. There are many different mediums on the market and some artists make their own, sometimes complicated, sometimes secret mixtures. But I recommend that you stick to the manufactured mediums – I do!

The first most important medium is turpentine. This you use to thin down the paint, for underpainting, and especially if you want to paint thin lines. (Not to be confused with turpentine substitute (white spirit) which you use for cleaning your brushes and palette, see page 10.) Some people find the smell of turpentine too strong, and if you are working in the bedroom or kitchen it is a little off-putting, especially just before lunch! Some people are also allergic to turpentine. Recently a new product has come on to the market, called 'Low Odour Oil Painting Thinner', and this has no smell, but naturally has the same properties (for oil painting) as turpentine. *I have used it for all the work in this book.*

Because oil paint takes a long time to dry, I find it very helpful to use a medium that speeds up the drying time. I use Alkyd medium. This is a liquid which helps thin the paint *and* speed up the drying process. I also use Gel medium; this is squeezed out of a tube and helps to spread the paint without thinning it too much and, like the Alkyd medium, it has a drying agent added. *I have used these mediums for all the work in this book.* I am very happy using these mediums for all my work, and I suggest you use them and forget at the

Fig. 11 My old Art School palette

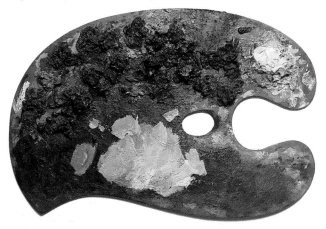

moment that others exist. Daler-Rowney have now marketed a new white paint – Alkyd White. Used in place of oil white, it speeds up the drying process by half and, as white paint is used constantly throughout a painting, it is a great aid for artists who want their paintings to dry more quickly. Try it.

Palette

There is nothing mysterious about an artist's palette. It is simply the surface on which the paint is squeezed from the tube and mixed before being applied to the canvas. Palettes are made from either wood or white plastic; some artists use glass placed on a table. The traditional palette shape is called a studio palette, but the oblong shape (**fig. 8**) is very popular today. Keep your mixing area cleaned when you are not using it. Clean it with painting rag and turpentine substitute (white spirit). **Fig. 11** is a photograph of my old Art School palette. Don't let yours get into a state like this! It lives in my studio today only as a reminder of those happy days, not as a palette for working on. It is almost a piece of creative art in its own right!

Easels

Your painting surface must be as steady and firm as you can make it, therefore a good strong easel is important. Some easels are illustrated in **fig. 12**. Table easels are perfectly adequate if you haven't got the space for a floor standing easel. Also, you can make do by placing your painting surface on a kitchen chair and leaning it at an angle against the back of the chair. Most oil colour sketching boxes (**fig. 13**) use the inside of the lid to put canvas boards on. You rest the box on your knees when working outside, and on a table when indoors, and the lid becomes the portable easel.

Carrying Box

A drawer in which to put all your equipment when you are not working is ideal, but if you are going to work outdoors then you have to carry your equipment. You can either find an old small suitcase, canvas carrying bag or, of course, buy one of the ready-made ones on the market. **Fig. 13** is a typical sketching box. It carries all your requirements except paint rag and, as I said earlier, is also an 'easel' for small-size work.

Whatever your hobby or pastime, where you need equipment, it is so easy to get carried away, money permitting, into buying too much. Don't let me stop your enjoyment of trying out new materials, but *until you have gained experience* of what you really need, keep them down to a minimum. Then, go out and treat yourself, and experience different brushes, colours, supports and anything that takes your fancy.

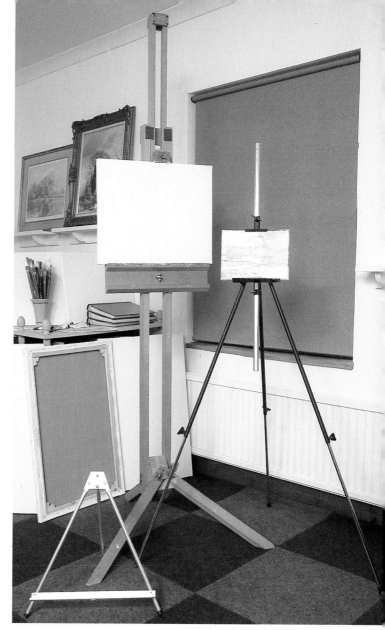

Fig. 12 (*above*) Selection of easels
Fig. 13 (*below*) Oil colour sketching box

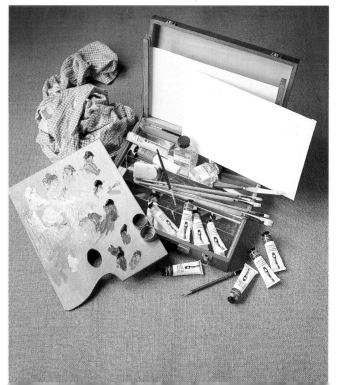

BEGINNERS' BASIC EQUIPMENT KIT

After reading the last few pages on equipment, you may be getting a little confused as to what you need just to get started. This is why I have listed the materials that will cope with all the exercises in this book, and have called it the Beginners' Basic Equipment Kit (**fig. 14**) and, in fact, I have used these materials to paint the exercises.

Colours Cobalt Blue, Crimson Alizarin, Cadmium Yellow (Hue), Yellow Ochre, Raw Umber, Viridian (Hue), Cadmium Red (Hue) and Titanium White.

Brushes Remember I said earlier that brushes are a very personal choice. The ones I am using may not be the best for you, but to get you started try them. It is best – but not essential – if you get two of each size. This will enable you always to have one to use for dark colours and one for light colours. In this way you can keep a dark colour in your brush and not have to wash it out to use a lighter colour. This can save a lot of frustration for you during a painting. If you want to use more brushes, then do; there are no rules, or good reasons why you should not.

The brush series is Bristlewhite Series B48 Nos. 1, 2 and 4, plus a Series 43 sable No. 4, a Dalon Series D99 No. 2 and a Series 103 sable No. 1 (Rigger). These last three brushes are for small and detail work.

Additional items Palette Knife, 76 mm (3 in) blade; oil painting medium or turpentine; a bottle of Alkyd medium or a tube of Gel medium; and a double dipper for your palette to hold the oil painting medium in one and Alkyd medium in the other. An old jam jar for holding your turpentine substitute for washing out your brushes; a paint rag for wiping and cleaning brushes and hands; a palette; canvas board or oil painting paper; a plastic eraser and an HB pencil.

Naturally there are ways of cutting down this basic equipment kit if funds don't allow you to get everything in one go. The most obvious saving would be to cut down the amount of brushes. Use only Gel medium and turpentine; find your own receptacles to hold them in and use a piece of old Formica or varnished plywood for a palette.

When working outdoors the only additions you will need to the above materials are a stool, a portable easel and, of course, a carrying box. Incidentally, the one illustrated in **fig. 13** can be bought empty and the paints and brushes etc. can be of your choice.

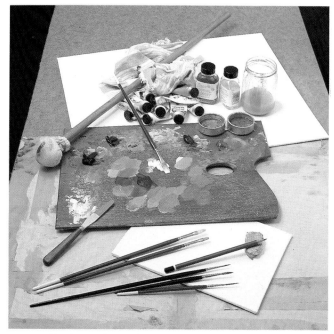

Fig. 14 Basic equipment

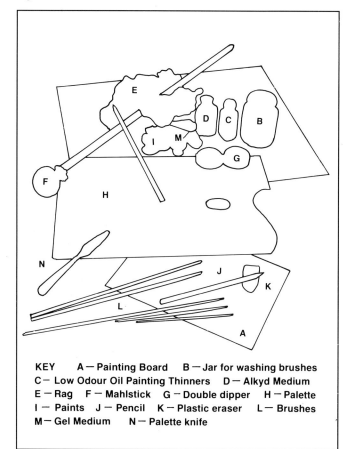

KEY A — Painting Board B — Jar for washing brushes
C — Low Odour Oil Painting Thinners D — Alkyd Medium
E — Rag F — Mahlstick G — Double dipper H — Palette
I — Paints J — Pencil K — Plastic eraser L — Brushes
M — Gel Medium N — Palette knife

GETTING TO KNOW OIL PAINT

First Doodle

At last you can start to paint. But don't get too excited and rush ahead without first going through these early exercises even though they may look simple and may not over-excite your creative urges. Perhaps the old cavemen didn't have to go through these stages before they were let loose on the cave walls, but they had to start in a simple way as they were taught the art of painting. Although these exercises may appear easy, for most beginners this is the hardest part of learning to paint – just the simple act of putting paint onto canvas. It doesn't matter what shapes they paint, or the size or colour, they are afraid of making a fool of themselves in front of their family or friends.

This of course is very natural. They are trying to do something that is new and alien to them. I find that at this stage a beginner is at his most vulnerable. Because we all want to show off what we can do, we tend to take on too much, too early. Beginners will want to have a go at painting a picture, anything from mountains to large snowscapes, forests – in fact the type of picture that inspires them. A man who is inspired to drive in a Grand Prix motor race knows that he can't do it until he has learnt to drive a car first. In the same way, no one can paint a full-blooded landscape until he has learnt the basics of handling paint.

In fact, the worst thing that can happen to a beginner is to have a go at painting something like a complicated landscape, for instance, of which he has no hope of making a painting. He will be disappointed with his results and will believe he can't paint, and therefore he will never become an artist. But if a student painted a very simple subject first (after practising with paint and some simple techniques), let's say a banana, he would have reasonable success. I think that for a real beginner – I can't stress this enough – this is the most important point I can make. *Your first real painting must be of a subject that is very, very simple.* Then the chances of success are very great and we all know that success breeds success, and therefore you will approach your next painting with confidence. The more confident you become the better your paintings will be, and the more enjoyment you will get from painting. So we will take things from the very beginning, in a steady progressive order.

The first thing I want you to do is to play with your paint and mediums. We couldn't start more simply than that! I suggest you use a cheap form of support to work on; try oil painting paper. Put some paint on your palette and off you go. Try painting over a large area with only paint, then try it with Alkyd medium added. See what happens when you add only oil paint-

Fig. 15 Doodling

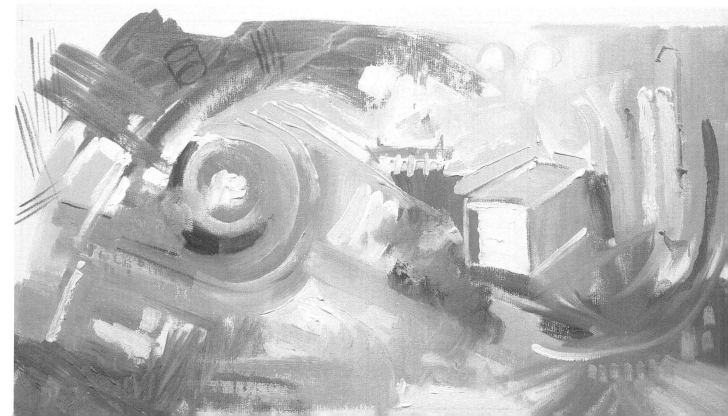

Paint with Low Odour Oil Painting Thinners added
Thursday 3.45 pm DRY 4.30 pm

Paint only (thin)
Thursday 3.50 pm DRY Friday 2 pm

Paint with Alkyd White added
Thursday 3.50 pm DRY Sat 11 am

Paint with 50% Gel medium added
Thursday 3.56 pm DRY 9 pm (thin areas)
(thick areas dry Sat 9 am)

Paint with 25% Alkyd medium added
Thursday 4 pm DRY 11.30 pm

Paint only (thick) Thursday 4.10 pm
DRY thin Sunday 3 pm
DRY thick approx. 2 weeks

Fig. 16 Approximate Drying Time-Table

ing medium or turpentine to the paint. Smudge one colour into another with your finger – a very useful painting tool! Add white to your colours to make them lighter. Try your small sable and nylon brushes and feel the difference to the hoghair brushes. Paint thinly, and also try using your paint thick. It doesn't matter how long you doodle in this way; in fact, the more you do, the more familiar you will become with oil colours, brushes and mediums. Because you are not worried about shapes (drawing), colours and creating an atmosphere in your work while you are playing with paint, all your learning power is concentrated on the application of paint to canvas. Don't worry if your family laugh at your strange pictures, show them **fig. 15** and let them laugh at mine!

Make Your own Drying Timetable

As you have been playing with paint, one thing you must have noticed is that the paint has not dried while you have been working. You have been painting 'wet on wet'. This is something you are going to have to come to terms with and learn how to work your paint while it's wet. You will find that you can get some lovely soft edges and merging of colours and tones while the paint is wet, but you will have more difficulty in getting hard edges. This will come with experience.

'Alla prima' is the name given to painting that is done where paint is worked directly onto the canvas, usually on a white ground, without first underpainting or using glazes during the painting. It is a direct way of painting, relatively unsophisticated and simplified, made popular over the last one hundred years by the many amateurs who took up oil painting. Basically you would be painting wet on wet throughout the picture.

There are variations; for instance, you could underpaint with a thin turpentine and colour wash first and then work over the top in a direct way. You could start a picture in this way, and leave it to dry, then work on it again, adding paint over dry paint to finish the painting. I have talked about alla prima because to me it is the basic way of oil painting, with variations, for beginners to start.

Questions I am often asked by students are: 'Do I have to wait for the paint to dry. . . ?' 'Do I use thick paint or thin paint?' 'Can I do a painting in one sitting?' 'Do I have to underpaint first?' These are very important questions and painting in a direct way (alla prima) in fact answers them all. If you were to go out into the countryside to paint a scene and you were there for the day but knew you would not be going back, you would *have* to paint your picture in one sitting. In the process of painting you would use thin and thick paint to get variation of texture and depth of tone, and you would have to work wet on wet to

16

finish the painting in one sitting. If you were using mediums with drying agents added you might find that some parts of the picture would be dry enough (as the day progressed) to over-paint without pulling up the paint underneath. You could then take it a stage further by adding some dark or light accents or even, after the painting was dry, change some small passages at home to finish it off. But beware, too much work at home, away from the real life scene, can ruin a painting done on the spot. Experience is the only answer here.

You might find you paint as far as you can working wet on wet and then *have* to let certain parts dry to be able to paint over them to continue the picture. Don't worry about this; it is a natural way of painting in oil. I could write about all the variations on what parts of a picture could be left to dry or painted wet on wet for the rest of this book, but the best way is to work at it and find out what happens in practice. As the drying time of the paint is so crucial to our way of painting, I suggest you make yourself a drying time-table. This will give you first-hand experience of paint drying time and a reference for the future, until it becomes second nature. Prepare this drying time-table on a durable surface (painting board or hardboard) and copy what I have done (**fig. 16**). Naturally add some more combinations to your chart if you want; remember, your chart is a working tool for *your* painting. After playing with the paint earlier you will know just how liquid or stiff you want your colours to be. Therefore the amounts of medium that you put in will be very personal to *you*.

Painting Definite Shapes

The most important skill to learn is to be able to paint up to a particular area of your painting and have control of the brush, so that it will keep within the boundaries you want. If you were painting the hull of a boat, you would want it to stay that shape and not one dictated to you by an uncontrollable brush! So it is very important to practise with your brushwork, until it becomes second nature to you; in fact, your brush will become an extension of your eye. What shapes you can see, your brush will be able to create on your canvas.

In **fig. 17** you will see two types of arrow. I have used these arrows in various places in the book to help you to understand the movement of the brush strokes. The solid black arrow shows the direction of the brush stroke, and the outline arrow indicates the movement of the brush in relation to the canvas, i.e. working from top to bottom, or bottom to top. We will start by painting up to a straight line, as shown in **fig. 17**. Practise on all these exercises, using different size

brushes, because during a painting you have to paint shapes of different sizes, and it may not be practical to change to a different size brush at that time. When you are painting up to a definite line, after loading your brush let your first brush stroke start to the right of the line. This ensures your paint is 'running' well out of the brush in the right consistency, and it also gives you a 'practice run'. Then repeat this again, getting closer to the line, and finally let your brush stroke hit the line you are painting up to. This, of course, is done in seconds and you will find that it is a movement that becomes almost as one when you have got used to it.

Naturally there are times when you can't start working your brush on the canvas before you paint up to a line but, by practising this way, when the occasion does arise you will be pretty confident to go straight in and hit the line the first time. Also practise painting up to a line on its left. You will find this more difficult (unless of course you are left-handed), but

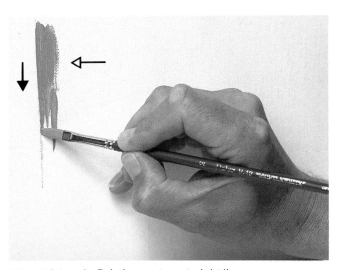

Fig. 17 (*above*) Painting up to a straight line
Fig. 18 (*below*) Painting up to a curved line

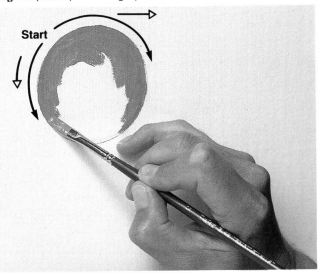

with a little patience you will be able to do it.

Now we will work to a curved line and paint a solid circle (**fig. 18**). With an HB pencil, draw round something to create a circle on your canvas. Then start at the top and work down the left side to the bottom, letting the bristles follow the brush, i.e. pulling the brush down. Remember, as with the straight line, work a couple of practice runs before you hit the line. Now start at the top again and paint the right-hand side of the circle. As with the straight line where you paint up to the left side of the line, you will find it more difficult, but it will come with practice. And it's no good turning the canvas round and painting it like the first side. What happens when you are working on a large canvas or mural? But ten out of ten for thinking! When you have done this, simply fill in the centre with the same brush.

Fig. 19

The next exercise, a kitchen spatula (**fig. 19**) is a little more difficult. The shape is more complicated and you have to fill it in first and then paint in the background, working up to the edges of the spatula with the background colour. It is a silhouette, and we are using it only to illustrate shapes, not as a three-dimensional object.

Holding the Brush

There are two basic ways of holding the brush. As you have been working on the previous exercises, I would imagine that 99 per cent of you have been holding your brush as you would hold a pencil. Well, for the exercises you have been doing, this is correct. However, where you have to work over wet areas of paint and you want to steady your hand for careful brush control, then you use a mahlstick. This is a long stick – mine is 46 cm (18 in) long – and the end has a lump of rag fastened onto it. Hold it in your left hand and rest the padded end on the edge of the canvas, or on any part of the easel that will support it. Then you can rest your hand on the stick to give it support (**fig. 20**). The position shown in **fig. 21** is for painting more freely and over larger areas. The brush is placed across the palm of the hand and held firmly by the thumb and first finger.

Naturally there is a variety of ways to hold a brush. You might be perfectly happy holding it one way, while for someone else it could be uncomfortable. If you start by practising these two important basic positions, through experience you will find *your* 'natural' way of working your brush.

Fig. 22 shows how to paint a horizontal line. Hold the brush in the 'detail' position, turn the hand half round to the right and drag the brush across the canvas from left to right. Remember, when you are drawing a line like this, to make sure your paint is 'runny' enough. If not, add Alkyd medium or turpentine to thin it. The curved lines above the horizontal were drawn in exactly the same way, except the hand moved up and down to create the curves. Practise painting both the horizontal and curved lines.

Finally, I have illustrated the 'dry brush' technique (**fig. 23**). This is a very traditional brush stroke and is used with all other painting mediums. It gives a lot of movement and life to an area. It can create the illusion of dappled sunlight on water, a rough earth field, texture on a plaster wall, etc. Don't fill your brush to capacity, fill it about one quarter full and then drag it across from left to right, lifting (less pressure) the brush as it travels along. You will find that the paint will hit and miss the canvas, leaving areas unpainted. Then have a go at the harder way – right to left! As you practise the dry brush stroke you will find your own ways of creating this very useful and versatile technique.

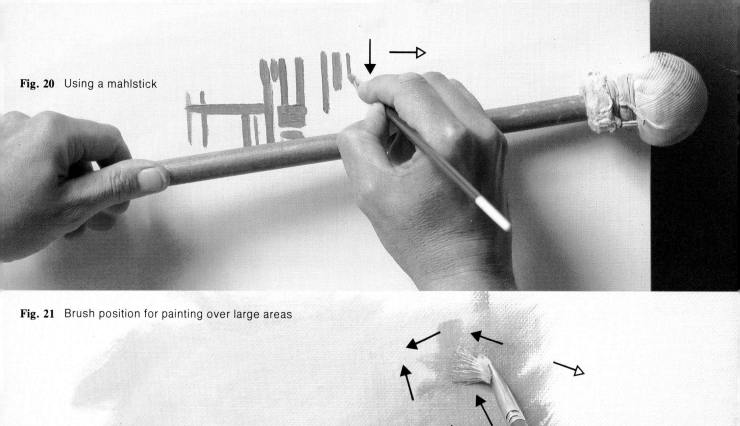

Fig. 20 Using a mahlstick

Fig. 21 Brush position for painting over large areas

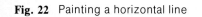

Fig. 22 Painting a horizontal line

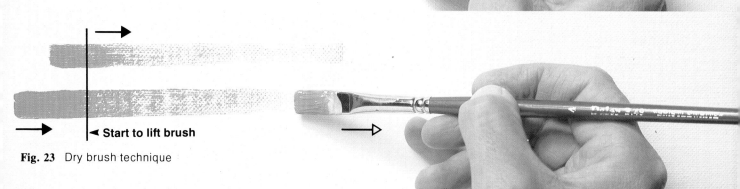

◄ **Start to lift brush**

Fig. 23 Dry brush technique

DRAWING YOUR PICTURE

I am constantly asked by students how important drawing is when you are painting. The answer is that it is very important, yet you can paint without being a draughtsman. This sounds very contradictory, and I will try to explain.

Let me first make it absolutely clear that to have the skill of drawing is a bonus for any aspiring student, and using it to plan and draw your picture before painting will give the picture a foundation upon which you can work with confidence right from the beginning. But painting is not just *drawing* shapes to make a picture. It is a combination of colours, tones and shapes that eventually all build together to produce the picture. It is more important to get the colour and tonal values correct than to produce a perfect drawing. A picture that is weak on drawing but strong on colour and tone will look good, but the end result of one where the colour and tonal values are weak, no matter how good the drawing, will be a poor painting.

Taking good drawing at one end of a scale and good colour and tonal values at the other end, naturally there are many places in between that will produce good paintings. After all, how good is 'good drawing' and how good is 'good colour and tonal work'? If you want to be a very realistic and detailed painter, then you *must* be able to draw well, as the results you are looking for with your finished paintings are dictated,

to a large extent, by careful observation and drawing. You will find, when you are oil painting, that you will cover up some of your drawing with paint. This is inevitable and you will therefore have to re-draw with paint, so it is important that, until you gain experience, you always have a reference to work from. You can then refer back to this during the painting of your picture, e.g. a still-life object; a real life scene (making sure you have enough time to finish your picture if you are not going back to the same place again); a sketch, and so on. If you are without a constant reference, your picture could quite easily wander away from its original concept. Some experienced artists work this way, and let the creation of the picture unfold as they work. It's a bit too early at this stage for you to try working like that.

Finally, whatever your skill at drawing, don't let it put you off painting. It is a natural course of things that the more you paint, the better your drawing will become. If you feel you need more experience, then draw objects in your home as extra exercises. Spend just half-an-hour a day practising and you will notice the difference. I have gone into this subject of drawing and perspective more deeply in some of my other books in this series.

To apply the drawing to the canvas you can use either charcoal, pencil or paint. I have never used

Fig. 24

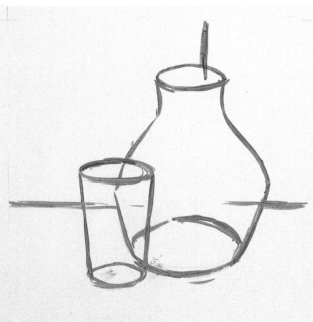
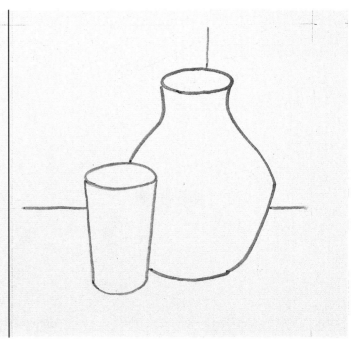

charcoal, because it is messy, and the 'dust' it leaves on the canvas surface can mix with your paint and discolour it. I find pencil all right, except that you can easily lose the image when you are painting. Finally, you can use a small sable brush – I use a Rigger – with a mixture of turpentine and a colour.

I work two ways. If there is a lot of careful drawing to be done in a picture, I draw it first with an HB pencil, then paint over the lines with Cobalt Blue diluted with plenty of turpentine. I feel more relaxed doing the drawing carefully with pencil. The reason why I then paint over the pencil is that the paint line will not disappear when you paint the picture as the pencil line could. When I work over with the paint drawing I do not try to copy my pencil lines exactly, or the freedom would go out of the drawing; in fact I very consciously loosen the drawing up. When you are drawing on the canvas, don't draw carefully laboured lines (**fig. 24**). You must put character into them; be bold and free. Feel and experience the picture as you draw it. See **fig. 27**. If a picture needs only a little drawing, then I will use just a pencil or a brush, or even paint without drawing at all, especially if it is a small picture.

Creating Form – 3-D Effect

Painting is really creating an illusion of 3-D objects onto a flat two-dimensional surface, and one of the ways of doing this is by adding light and shade (dark against light, light against dark) to our painted objects. For instance, if you look at **fig. 25** you can only see a flat yellow panel. If you now look at **fig. 26** you can see a yellow box. This all seems very obvious, but it holds one of the vital keys to painting.

Fig. 25 is a yellow background, with a yellow box painted on it, but without any light. Therefore there are no shadows, no light against dark, and consequently we can't see the box. In **fig. 26** a light is positioned top left, and you can see the box because of the shadows and tones cast by the light. Through light and shade we can see forms and shapes of objects.

A most essential part of painting from nature, whether it is from a still-life indoors or a landscape outdoors, is to screw your eyes up as you look at the subject you are painting. You will find that the middle tones disappear and you see the darks and lights of the scene quite clearly. This helps you to see shapes and forms, but also to know where your real darkest darks and lightest lights are situated. Get into this habit quickly; *it is very important*.

When you start any painting, always make a positive effort to remember from what direction the source of light is coming – obviously where the light hits an object will be the 'light side', and the opposite side will be the dark or shadow side.

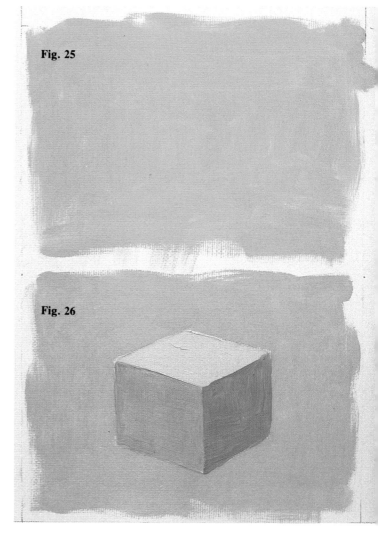

Fig. 25

Fig. 26

Fig. 27 (below)

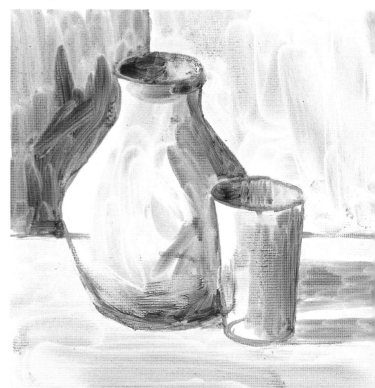

Underpainting (Blocking in)

The next stage for a painting, after drawing, is to underpaint it. Remember, however, I said earlier that you can also go straight ahead and paint onto the white canvas without underpainting. The painting on page 7 (**fig. 6**) is painted this way. I suggest you try all methods and techniques of painting, then you will know which way suits you best. The object of underpainting is to get light and shade (three dimensions) into your picture before you paint, so before you start worrying about colour you create your picture in just one colour (monochrome) (**fig. 27**). You have worked out where your light and dark areas are to be placed, the drawing has been done and then you have a firm foundation on which to work. Underpainting is done with one colour (don't add white to it) and mixed with plenty of turpentine, almost like applying watercolour to paper. This can be applied with a brush, or a rag on your finger or just your finger. The light areas are shown by leaving white canvas, the dark areas shown by adding more pigment (paint) to the turpentine. As this is applied thinly, it does not take long to dry (if you tried this mixture on your drying chart you will know roughly how long) and you can then paint the picture. The painting on page 5, **fig. 3**, was painted in this way. You can also work your paint when the undercoat is not quite dry, but only experience will tell you when and how to work over it.

Some artists take the underpainting a stage further and add additional colour to it. I can't see anything wrong with this at all; in fact, you are another stage closer to the finished painting. You can use any colour you like for your underpainting except, of course, a light colour, which will be difficult to see on the canvas. Raw Umber dries quickly and is therefore a good colour to use for underpainting and drawing the picture with a brush, but I mostly use Cobalt Blue.

After a support has been primed (white), a common way of working is to then put a wash (turpentine plus colour) all over the support to cover the white primer. Sometimes it's a cool blue colour or brown, orange or yellow ochre. This helps to give an all-over hue to the painting, because small areas of the background are left unpainted as they are missed by the brush as you paint the picture. Also, where you work the paint thinly it will allow the colour to shine through.

There is one other way of underpainting that the old and not so old masters could not do, and that is to use acrylic paints (only introduced as a painting medium in the early 1960s). The advantage is that they dry very quickly and do not have any effect on the oil paint when it is worked over the top. Note: the acrylic *must* be dry, and you *must not* put acrylic paint over oil paint. Naturally if you try this way of underpainting, use sensible precautions, e.g. use a brush for acrylics only and keep it washed out (or it will harden very quickly). Keep your acrylic paints totally separated from your oil paints. You can't afford to get the two mediums mixed up by accident as water (acrylic paints are water-based) does not mix with oil! I find it a good way to work. The painting on page 5, **fig. 2**,

Fig. 28 Using acrylic paints for underpainting

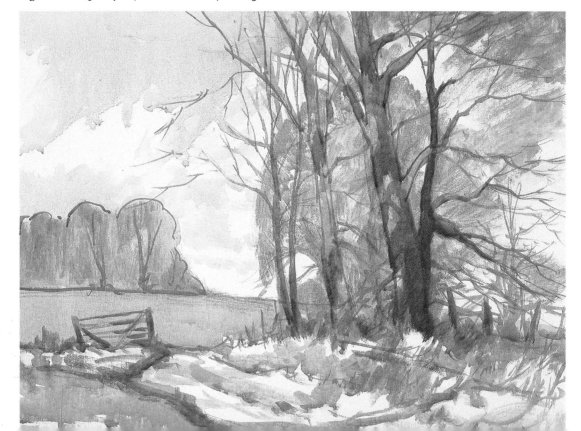

was painted in this way, and **fig. 28** is drawn and underpainted with acrylic paints.

Composition

Composition or design in painting is a very complex subject. One person could think a painting was a good composition; another would think it weak. I will go through some basic 'rules' which will be sufficient for you to apply to your paintings, but as you work you will learn more about design through your own experience of painting.

Some people have a natural talent for design and composition, while others find it difficult, like some students find drawing or colour mixing easy, and so on. I believe that everyone has a natural strong point and once you find yours you can then concentrate on some of your weaker areas.

Composition or design in painting means the same to me, namely, the positioning of objects on paper in a happy way that enables you to tell a story visually to the onlooker. Since any painting will finish up on a piece of paper or canvas with an edge around it, it obviously has to be designed within those boundaries. Let us then look at some basic, but important rules.

I was taught the following system at Art School. Look at **fig. 29**. I have divided the paper (canvas) vertically and horizontally into thirds. Where the lines cross at **a**, **b**, **c** and **d** are the focal points. If your centre of interest is positioned on or around a focal point, then you should have a good design. Don't have your centre of interest in the middle of the picture, as it will look too symmetrical (**fig. 30, left**). Placed at the focal point **b**, however, it becomes a good design (**fig. 30, right**). Look at **fig. 31** and you can see how the church positioned at **b** gives the picture a happy look (by which I mean that it works well on paper).

To give the centre of interest more importance to the picture, you can add colour either brighter, stronger, darker or lighter than its surroundings, or add an odd or unexpected colour.

The space between objects is also important to good design. An ugly space between objects can spoil a picture, but a pleasing shape can enhance it. Try to avoid two objects just touching; it can be difficult for the eye to separate them in a picture. The golden rule is to let important objects either 'hit' or 'miss' each other (**fig. 32**).

After going through these basic rules, don't feel you have to stick to them rigidly; they are a general guide from which you can work. A deviation from the expected to a more personal approach can create an original and sometimes unusual painting. When you wander around an exhibition, look at paintings and the way they have been designed. You will learn a lot from them, whether you are looking at old masters or modern artists' work.

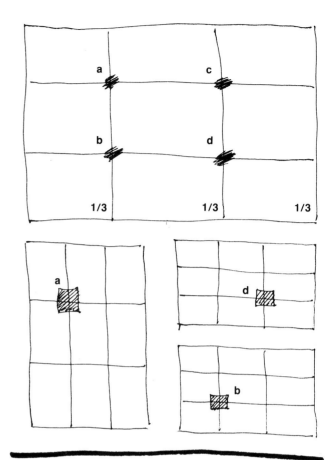

Figs. 29, 30, 31, 32 Composing a picture

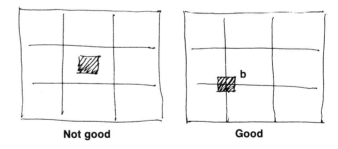

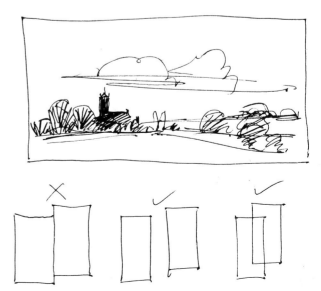

MIXING COLOURS

Now we come to what must be one of the most important aspects of painting: mixing colours. Wherever you are, everything you see is made up of colour. To a beginner, the thought of mixing all those thousands of colours and shades must be very daunting, especially when you can only buy between fifty to sixty ready-made colours. And even if you had them all on your palette, you would find that you never had the perfect colour you wanted. Well, you don't need hundreds of colours to work from at all. In fact, *all colours* can be mixed from just three: red, yellow and blue. These are called the primary colours (**fig. 33**), and they cannot be mixed from any other colours. There are other reds, yellows and blues, and they can vary greatly in tone. For instance, Cadmium Yellow, Cadmium Yellow Pale, Lemon Yellow, Yellow Ochre are all yellows, but look different when compared to each other. This means that although you are restricted to the primaries you still have a choice of colours.

One of the most important rules for mixing colours is always to put the main colour of the mix onto your palette first. For instance, if you want to mix a yellowy orange, then you would put yellow first and add red to the yellow, gradually mixing in the amount of red you need to make your yellowy orange. If you put the red on the palette first then the emphasis would be on red, and you would have to add a *lot* of yellow to make a yellowy orange. This is very vital to mixing the colours you want. First, learn to mix with just the primaries (red, yellow and blue), then you will be able to cope with almost any colour you see.

There are other colours that we use besides the three primary colours, and these help with our mixing. Gradually, as you progress, introduce some of these to your palette and you will find them very useful. Until you gain experience, use the colours I have used for the exercises in the book. Incidentally they are the colours which I use all the time for my oil painting. It is obvious, and you will no doubt have found out by now, that if you want a bright red, and the primary red you are using is Crimson Alizarin, then this won't give you a bright red colour and you will have to use Cadmium Red, for instance, instead. The point I am making here is that although you mix your colours using just the three primaries, you will find that to get some colours you need a different red, yellow and blue on your palette to help achieve the shade you want.

With oil paint, to make colours lighter we add white. When you are mixing a pale colour it is essential that you put white onto your palette first and then mix in the other colours. You can choose between Flake White and Titanium White. Flake White has more body (thicker) and dries a little more quickly, but I prefer to use Titanium White. Don't forget Alkyd White which dries twice as fast as the previous two; it may suit you, and it is another aid to quicker drying.

Look at the colour chart on the opposite page (**fig. 33**). In the first three columns I have painted different colours, using the three primary colours. First I have made each primary colour paler by adding white; then I have added one other primary colour; finally, to the resulting colour I have added more white to make the progression paler. In the fourth column I have mixed the three primary colours together to obtain the 'black' and then added variations of the primary colours plus white to obtain the other colours. Copy this chart and try to match my colours, and then try mixing your own colours and make your own chart.

Look around you at objects in the room and try to copy the colours. Don't mix too much colour, only enough to paint an area of about 7 × 7 cm (3 × 3 in). Remember that a colour changes slightly when it is placed against another colour. For instance, if you were painting the colour of your curtains onto your white canvas, it could look different to the actual curtain colour. However, if you then painted the wall colour that the curtain is resting against, you would find that the colour looks more realistic.

Some colours jump out from the canvas, while others seem to stay in the background. It is the warm colours – reds – that 'jump', and the cool colours – blues – that recede. Not only does this happen on the canvas, it does this in nature. That is why, looking at a landscape, the distance colour is overall blue, and the foreground colours are stronger and warmer. Next time you are out, look at the distance while you cover up the middle distance and foreground with your hand (look over the top of your hand) for about one minute. Then quickly take your hand away and look at both the distance and the foreground together. You will be surprised just how 'blue' the distance is, how colourful the foreground is, and how much warmer are the foreground colours.

You can't paint a picture, no matter how small, without mixing colours, so you will get better with every painting you do. Nevertheless do practise your mixing; you will get a tremendous thrill when you achieve the colours you were trying for. Make everything a personal challenge and you will enjoy even the most mundane of tasks.

Fig. 33

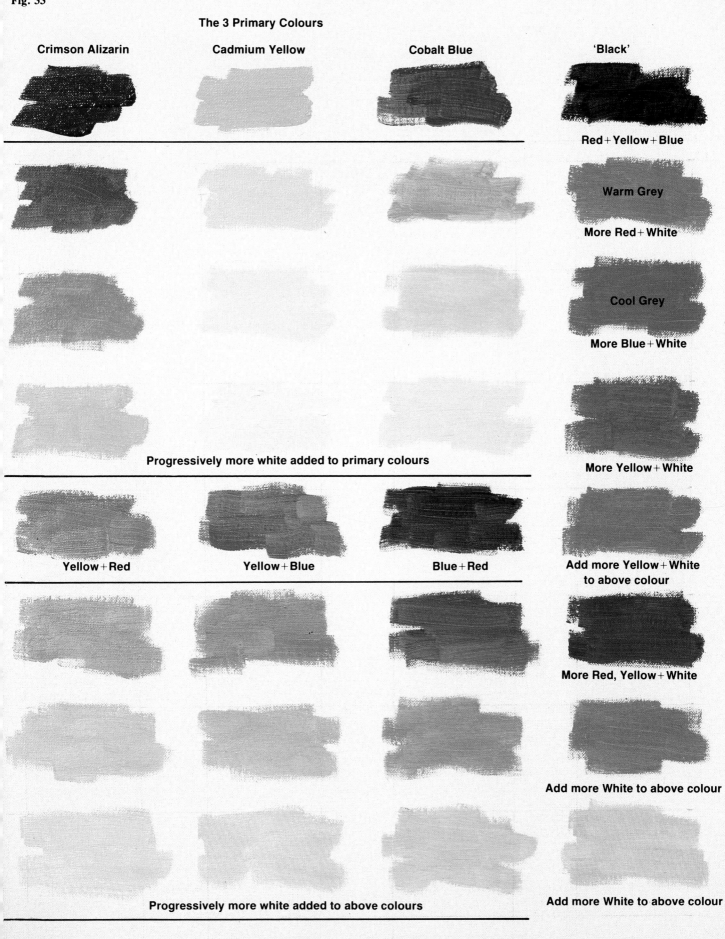

The 3 Primary Colours

| Crimson Alizarin | Cadmium Yellow | Cobalt Blue | 'Black' |

Red+Yellow+Blue

Warm Grey

More Red+White

Cool Grey

More Blue+White

More Yellow+White

Progressively more white added to primary colours

| Yellow+Red | Yellow+Blue | Blue+Red |

Add more Yellow+White
to above colour

More Red, Yellow+White

Add more White to above colour

Progressively more white added to above colours

Add more White to above colour

PAINTING A PICTURE
USING ONLY 3 COLOURS

Well, at last we are here! If you have been working page by page and not jumping forward, this will be your first real attempt at a painting. I have chosen a banana for the first exercise (**fig. 34**) because it can be long, short, fat or thin; greeny yellow, bright yellow or orangy yellow; in fact, from a painting point of view one banana can look quite different to another. This is important. Your drawing might not be quite accurate or your colours not exactly like mine but, because of the way bananas vary, yours will still look like a banana.

If your first painting had been, say, a scene of boats moored in a harbour (not a simple subject), then your drawing, your colours and inexperience could have combined to make it a disaster. It is far better to paint something simple first and be seen as someone who paints simple things well, than someone who paints complicated scenes badly, and is humoured by their friends. Time and practice will get you to the harbour.

I have done each exercise in stages. These are simulated, but the main exercises at the end of the book have been photographed at each stage of their development, so you can see how the same painting progresses until it is finished. Copying these exercises will give you confidence for when you begin to paint from life. However, don't try to copy my pictures exactly, as you will be too concerned over the drawing and find yourself getting tight and inhibited. The colours I have used are shown on each exercise. Before you start, look at the stages and see how I did the painting, so that you are familiar with the subject. Don't forget to keep each exercise simple, but if you find you go wrong or you can't get the effect you are after, leave it alone, go onto another exercise and come back with a fresh eye. The chances are you will be able to cope with it. When you have done these exercises, copy the real life objects.

Throughout all the exercises it is most important to mix your colours in the order that I specify in the text or as indicated in the illustration captions. Generally speaking, each colour you add will be less in quantity than its predecessor. If it is a very pale colour then it will have a large proportion of white as its first colour. For all the exercises in the book I have used *low odour oil painting thinners instead of genuine turpentine*, although naturally you can use either. I will refer to these thinners as turps. (As mentioned earlier, do not confuse with turps substitute which is for cleaning your brushes.) Throughout the book I have used Titanium White and also mixed Alkyd medium with my paint.

to help it spread and speed up the drying time. All the exercises in this section were painted one quarter larger than they are reproduced, except **fig. 35**, the finished painting of which was 14.6×13 cm ($5\frac{3}{4} \times 5$ in).

Banana First draw the banana (**fig. 34**) with an HB pencil; this will make you feel more confident when you paint over the pencil with Cobalt Blue mixed with turps (first stage). Use your Series B48 No. 1 brush. Next, paint in the banana with your Series B48 No. 2 brush. You may find you want the drawing to dry; I let mine dry and it took 20 minutes. For the third stage, mix a brown and paint in the dark marks and the stalk. This is painting wet on wet, as naturally the yellow is still very wet. Now, with the same brush, paint in the shadow using the colours indicated. Finally, mix up a light colour of a thick juicy consistency and in one stroke, working away from the banana, paint in the broken end of the stalk, still using your No. 2 brush.

Until you have gained experience *do not* apply your paint thickly, unless to show definite brush strokes to help illustrate form, as you did for the broken end of the stalk. If your paint is thick you will have great difficulty in painting over it with more paint, and your picture could easily turn into a muddy shapeless mess. You will find that the art of applying thick paint will happen in a natural way as you get used to the medium. As a guide, use thin paint for dark and shadow colours and thick paint for bright and highlight colours. The banana was painted on a canvas panel.

Eggs For this exercise (**fig. 35**) I used the smooth side of hardboard and painted on two coats of Hardboard Primer. Using your Series B48 No. 1 brush, draw in the eggs with a mix of Cobalt Blue and turps. If you feel happier, draw with your HB pencil first. Now, with your Series B48 No. 2 brush, using Cobalt Blue, paint in the background and shadows, and with your finger smudge in the soft shadows on the eggs. Mix the colours for the eggs and paint them in. Remember as they are very light coloured, put white on the palette first and mix your colour into it. Then paint in the background, using your Series B48 No. 4 brush. Finally, still using your No. 4 brush, paint in the shadows on the table with a mix of Cobalt Blue, Titanium White, Crimson Alizarin and a little Cadmium Yellow, and then paint the table. 'Clean up' the edges of the eggs with your Rigger No. 1 brush.

Fig. 34

Cobalt Blue

Cadmium Yellow, Crimson Alizarin and Titanium White

Crimson Alizarin, Cadmium Yellow, plus a little Cobalt Blue and Titanium White

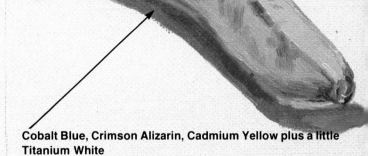

Cobalt Blue, Crimson Alizarin, Cadmium Yellow plus a little Titanium White

Crimson Alizarin Cadmium Yellow Cobalt Blue

⟵————————————— **Plus Titanium White** —————————————⟶

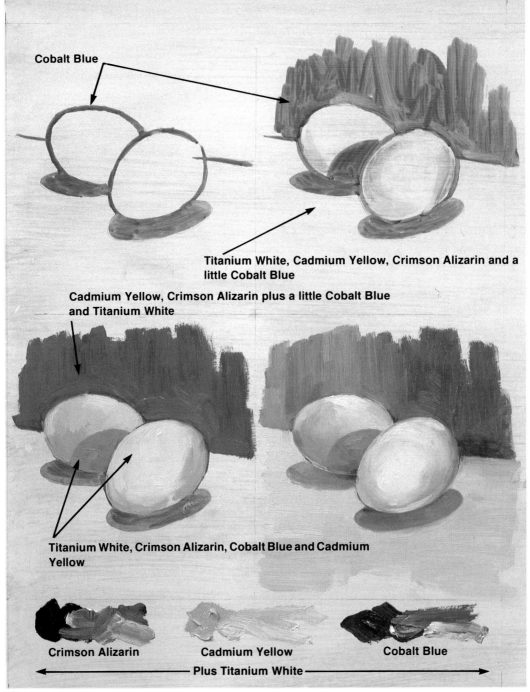

Cobalt Blue

Titanium White, Cadmium Yellow, Crimson Alizarin and a little Cobalt Blue

Cadmium Yellow, Crimson Alizarin plus a little Cobalt Blue and Titanium White

Titanium White, Crimson Alizarin, Cobalt Blue and Cadmium Yellow

Crimson Alizarin Cadmium Yellow Cobalt Blue

◄──────────────── Plus Titanium White ────────────────►

Fig. 35

Jam Jar Beginners are always afraid of painting glass because they think it is too advanced and too difficult to paint. The secret is to observe. Observation means looking very carefully, but understanding what you are seeing. Put a drinking glass in front of you and you see glass! It may have different colours and shapes that show the form of the glass, but that's all you see. Now look at it again and ask yourself, what is behind the glass? What makes those shapes? By looking carefully you will see that, for instance, a table-edge or an apple from the fruit-bowl can be seen *through* the glass. Now look at each shape against the next and, if you do this for a few minutes, you will find that you are not looking at a glass but at *shapes* that are *through* the glass.

At this point you are capable of painting your glass. The way to do it is to paint the *shapes* you see, then half-close your eyes and look for the shadows and high-lights on the glass, and put them in. There is one very important rule to remember: the colours of the shapes seen through the glass are usually darker than the ones seen outside the glass. In the exercise (**fig. 36**) you can see that the jam jar is made up of coloured shapes. Notice the 'black' background on the top left, I have painted it lighter in the jar – it appeared that way. I drew it in with my Rigger No. 1 brush and used my Series B48 No. 4 for the rest of the picture, except for detail work in the last stage, where I used my Series B48 No. 1 and Rigger No. 1. I painted this exercise on a canvas.

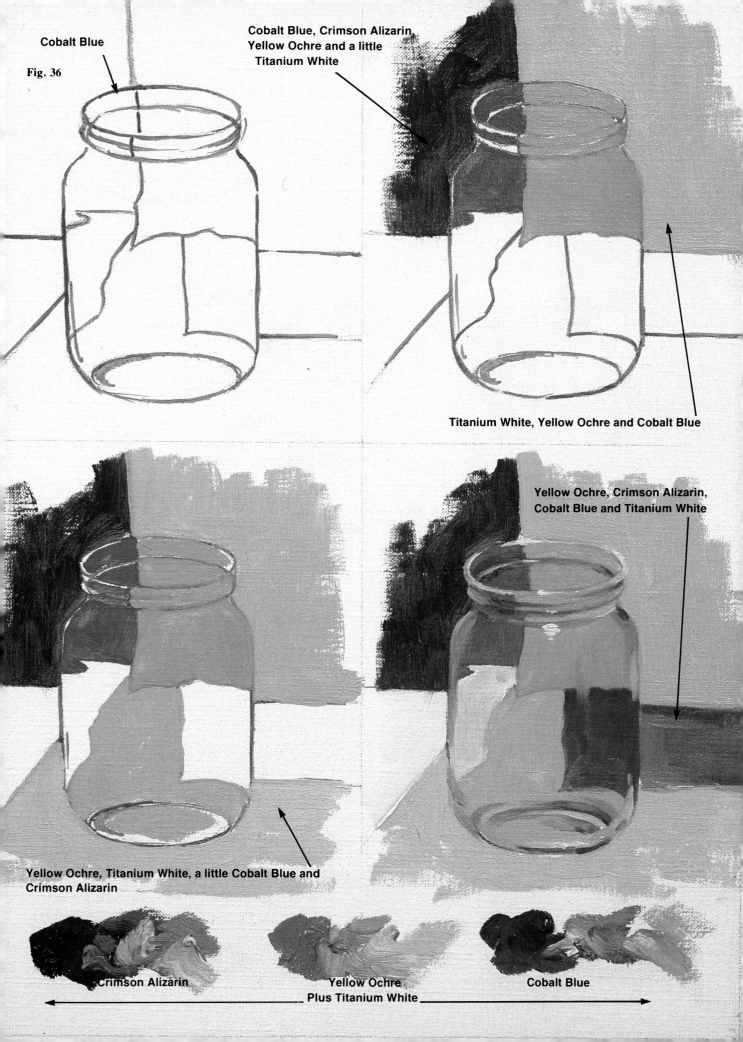

Cobalt Blue

Fig. 36

Cobalt Blue, Crimson Alizarin,
Yellow Ochre and a little
Titanium White

Titanium White, Yellow Ochre and Cobalt Blue

Yellow Ochre, Crimson Alizarin,
Cobalt Blue and Titanium White

Yellow Ochre, Titanium White, a little Cobalt Blue and
Crimson Alizarin

Crimson Alizarin Yellow Ochre Cobalt Blue

Plus Titanium White

Fig. 37

Cobalt Blue

Cadmium Yellow, Titanium White and Cadmium Red

Cobalt Blue, Cadmium Red plus a little Cadmium Yellow and Titanium White

Cadmium Red plus a little Cobalt Blue, Cadmium Yellow and Titanium White

Cadmium Red

Cadmium Yellow

Cobalt Blue

← ————————————— **Plus Titanium White** ————————————— →

Strawberry with grapes I have changed one of the primary colours for this exercise (**fig. 37**), which I painted on a canvas panel. I have used Cadmium Red, Cadmium Yellow and Cobalt Blue. The reason for the new red is because Crimson Alizarin would not be the colour for a strawberry.

Start by drawing in the picture with your Rigger No. 1 using Cobalt Blue mixed with turps. (Draw it in pencil first if you prefer.) Then, with the same colour, paint in the shadows and grapes, using your Series B48 No. 2 brush. Next, with your Series B48 No. 4 brush, paint in the background with a mixture of Cadmium Yellow and a touch of Titanium White and Cadmium Red. Note how I left highlights on the grapes when I painted them in blue and how they follow the curve of the grape. With your Series B48 No. 2 brush, paint in the grapes, leaving the existing highlights unpainted. Paint in the strawberry, using pure Cadmium Red then, with a very little touch of Cadmium Yellow and Titanium White added, paint over the light tones; add a little Cobalt Blue to Cadmium Red for the dark areas. Now put a light blue/grey over the highlights on the grapes, and then in the middle of the highlight put a bright spot of Titanium White with a touch of Cadmium Yellow mixed in. Next, paint in the grey background and yellow/white tablecloth with shadows. Paint the stalks of the grapes and strawberry. Finally, clean up and add accents of dark and light where you feel necessary with your Rigger No. 1. This is the most difficult painting so far; if you have difficulties try again, and if you are still not satisfied, go on to the next exercise, and come back to this one later. Good luck!

Prawns I did this exercise (**fig. 38**) on canvas using the same three primary colours as for the last exercise. Start as you did there, by drawing in with a mix of Cobalt Blue and turps, using your Rigger No. 1.

Now paint in the top prawn with your Series B48 No. 1 brush. Let the brush strokes follow the shapes of the scales on the back of the prawn. Here is a very important rule to remember. Always paint your brush stroke in the direction that the object is growing or going. For instance, if clouds are moving from left to right, then paint them with brush strokes working from left to right. Naturally there are times when this can't be done, but get into the habit; it will give your pictures tremendous life and movement.

Next, paint in the plate and carry on painting in the other two prawns. Leave their feelers, or areas where the feelers will cross, until the background is finished, e.g. the feelers of the bottom left-hand prawn overlay the bottom right-hand prawn and therefore can't be painted in until the right-hand prawn is finished. Now paint in the shadows and finally paint in the feelers, using your Rigger No. 1.

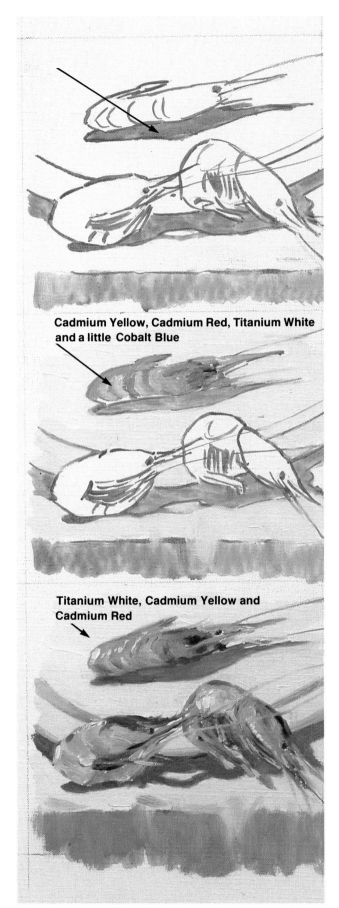

Cadmium Yellow, Cadmium Red, Titanium White and a little Cobalt Blue

Titanium White, Cadmium Yellow and Cadmium Red

USING A PALETTE KNIFE

For most of us, when we think of palette knife painting we visualize thick juicy paint being mixed and spread over a canvas or painting board, and the finished painting being very colourful and Impressionistic, with lots of thick paint standing out in relief off the canvas. Well, that is one way of working with a painting knife and, as you can imagine, a very exhilarating and exciting way. You can really let loose your passion for a subject as you move the thick paint around the canvas, feeling your way, making shapes and mixing colours. One word of warning: make sure you have enough paint before you start as it goes very quickly working this way!

Working the paint thickly is one way of using the painting knife, and another is to work the paint with the knife as you would with a brush, and gradually use thicker paint for important areas, or where thick paint will help to tell the story in the painting. In **fig. 41**

Fig. 39

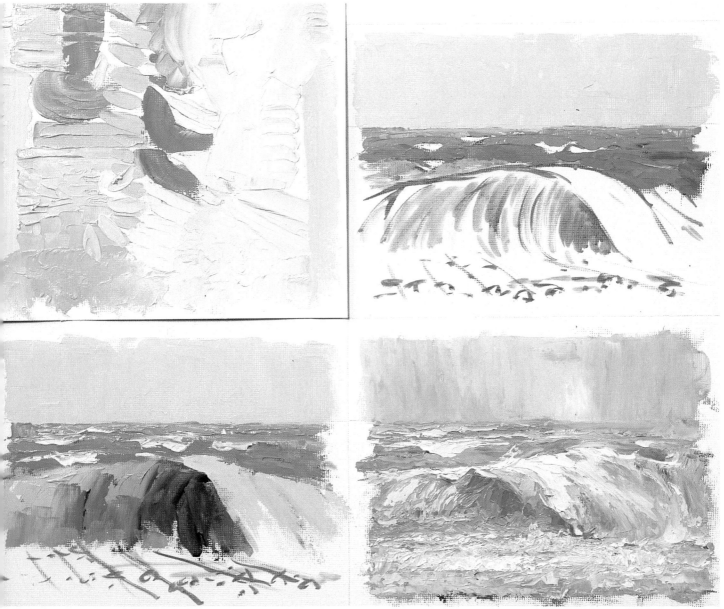

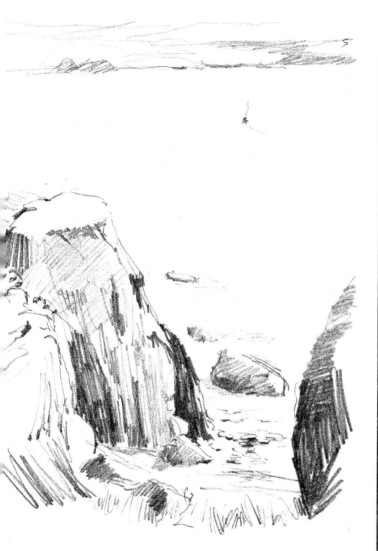

Fig. 40 Pencil sketch of Fig. 41

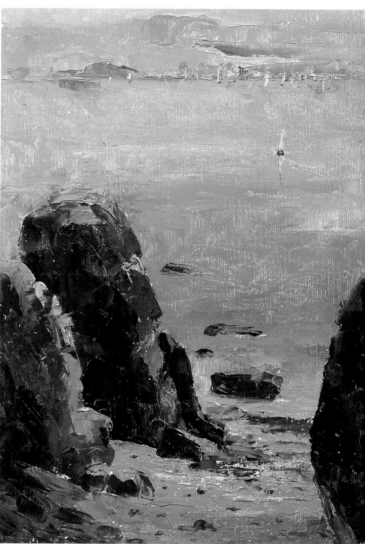

Fig. 41 From the Cliffs

the sea is very thin – in fact, you can see the grain of the oil sketching paper through the paint in most areas, but I have used thicker paint for the cliffs and rocks.

Once you have mastered using palette knives you will be surprised at the amount of detail that you can get into your painting. Naturally, the mixing of colours, the design, choice of subject and the general 'rules' of painting also apply to palette knife painting; the difference is the instrument with which you apply the paint, and the marks it makes. Therefore as you have to master the brush, so you have to master the palette knife. There are different palette knives as there are different brushes, and the choice is personal. But to start you off I suggest you use the three knives with which I worked the above painting (**fig. 41**). This is a painting I did from a pencil sketch worked on the spot (**fig. 40**). Use these knives until you gain experience and then, if you want, add to them from your own choice.

The three are: No. 521 short trowel shape, No. 524 small pear shape, and No. 554 cranked blade 76 mm (3 in) (**see fig. 10** on page 11). Start by experimenting (doodle) on a piece of canvas paper like you did with your brushes (**see fig. 39**). Try using paint very thick, getting different marks from the blades. Scrape the paint off to allow the grain of the paper to show through. Make marks with the edge of the blade, simply try anything you can think of. The suggestion of yacht sails in the distance in **fig. 41** was achieved by putting the blade on edge and lifting it off the paper. Try it on your doodle.

Now begin the exercise (**fig. 39**). This was worked on oil sketching paper and the size I painted the picture was 28 cm (11 in) wide. Draw it in first with your Series B48 No. 1 brush with a mix of turps and Cobalt Blue, then work through the stages. On the last stage I used plenty of paint and, in the foreground, did a lot of mixing on the paper. Add Gel medium to the paint, it helps it dry more quickly and can help you to spread the paint. Good luck!

WORKING FROM PENCIL SKETCHES

There are many times when it is impractical to take your oil painting equipment with you to paint outdoors. The only way around this is to make some pencil sketches and copy from these at home. Make colour notes on your sketch, or on the back of it. You will find that you can very easily devise your own code system to save time and space. For instance, S = sun, P.F. = ploughed field, GR. = green, P. = pale etc.

But before you reach this stage there is still another aid to help your pencil sketch: the camera. But please take note: *photographs can never take the place of working directly from nature, or be a short cut to your own personal observation and experience of landscape.*

Having said that, how can the camera help? If you were to sketch a scene in pencil and then photograph the same scene, you would have an indication of colours to help with your memory and notes. The photograph would also show details of subjects, where the sketch was inadequate. A photograph is also a perfect trigger to remind you of parts of the scene, the type of day, and many other incidents, that help to add more information to your sketch, which in turn will enable you to use the sketch to produce an oil painting. I suggest you take transparencies as these can be greatly enlarged, and this helps you not only to see much more than you would from a 7 × 10 cm (3 × 4 in) print, but it can give you a feeling of being at the scene again, especially if the transparency is on a screen about 1.2 metres (4 feet) across.

Start by sketching simple subjects to work from. Remember, don't run before you can walk, and use the camera sparingly and wisely.

Straw Bales This first exercise (**fig. 42**), was sketched very simply, using a 2B pencil on cartridge paper. There are no details drawn in, apart from the suggestion of the birds; it is all broad tone work. I painted the picture 28 cm (11 in) deep × 20 cm (8 in) wide. Before I started, I painted a watery wash of *Acrylic* Cadmium Yellow and Crimson Alizarin over the canvas to give me a warm base on which to work. It was the type of warm summer day when storm clouds keep threatening rain but it never comes. Make sure the acrylic paint is absolutely dry and then, using your Series B48 No. 1 brush, with a mix of turps and Cobalt Blue, draw in and fill in the first stage using your sketch as a reference. Now paint in the blue sky, using your Series B48 No. 4 brush and a mix of Titanium White, Cobalt Blue and Crimson Alizarin. Then paint in the dark clouds, using Cobalt Blue, Crimson

Alizarin, a little Yellow Ochre and a little Titanium White. Paint the trees with your Series B48 No. 2 brush, using a mix of Cadmium Yellow, Cobalt Blue and Crimson Alizarin; then add a little Titanium White to the trees on the left of the dark one. For the corn stubble and straw bales use Yellow Ochre, a touch of Crimson Alizarin, Titanium White and a little touch of Cobalt Blue. For the highlights on the bales and the field use Titanium White and Cadmium Yellow.

Notice in the field how some of the underpainting shows through. Paint the straw bales with your Series B48 No. 2 brush, and use your Series B48 No. 4 brush for the field. The shadow in the foreground is mixed with Cobalt Blue, Crimson Alizarin, Yellow Ochre and a little Titanium White.

Hartford Woods This next exercise (**fig. 43**) is a little more complicated than the last one, but I have tried to simplify it by keeping my pencil sketch simple and not fussy. It was done on cartridge paper with a 2B pencil and is nearly all tonal shading, like the straw bales exercise. First, draw the painting in with your Series B48 No. 1 brush, and then, using your Series B48 No. 4 brush, fill in the solid area. As usual, use a mix of Cobalt Blue and turps. Paint the sky in next with Cobalt Blue, Titanium White and Crimson Alizarin using your Series B48 No. 2 brush.

With the same brush and a mix of Cobalt Blue, Viridian, a little Crimson Alizarin and Cadmium Yellow, paint in the 'dark blue' background trees and the foreground trees. Still using your No. 2 brush, now paint in the tree trunks with a mix of Titanium White, Cadmium Yellow, Cobalt Blue and a little Crimson Alizarin. Use less Titanium White with this mix for the shadows on the trunks. With the same colour, using your Rigger No. 1 brush, next paint in the thin branches.

Finally, work the ground, using Titanium White, Viridian, Cadmium Yellow and Crimson Alizarin. Paint up to the existing shadows (underpainting) with your colours and then, adding more Cobalt Blue to the ground colours, paint over the existing shadow areas, and add a few more shadows in the distance. With your Series B48 No. 2 brush without paint, rest the bristles on the grass below the long shadow and 'flick' the brush upwards and off the canvas almost at the same time. This gives the illusion that the shadows and the grass in front of them are interspersed. It is a good idea to practise on a piece of paper painting ground and grass effects. It's an important part of landscape painting.

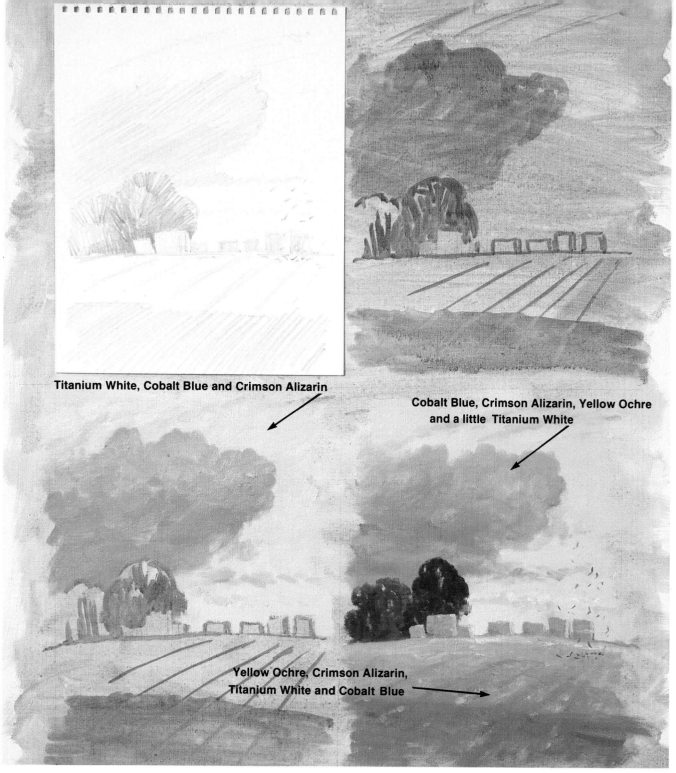

Titanium White, Cobalt Blue and Crimson Alizarin

Cobalt Blue, Crimson Alizarin, Yellow Ochre and a little Titanium White

Yellow Ochre, Crimson Alizarin, Titanium White and Cobalt Blue

Fig. 42 Straw Bales

Cockerel I did pencil sketches of the chickens and cockerel (**fig. 44**) with a 2B pencil on cartridge paper and also took photographs (slides) of them to help me with the colours.

In the first stage, after drawing in with my Rigger No. 1, I painted the foreground using my Series B48 No. 4 brush and also my finger. I used my Series B48 No. 2 brush for the cockerel, and Rigger No. 1 for the eye. Start by putting a very turpsy wash of Cadmium Yellow and Cadmium Red over the cockerel except

the tail. Then work from the head to the tail, making sure your brush strokes follow the shape and direction of the feathers; be bold and not fussy. I painted the background in last, but I also reshaped some feathers back over the background. Use various mixes of Cobalt Blue, Viridian and Cadmium Red for the black feathers, and for the brown feathers use various mixes of Cadmium Red, Crimson Alizarin, Cadmium Yellow and Cobalt Blue. Also mix Titanium White where necessary for both colours of feathers.

Fig. 43

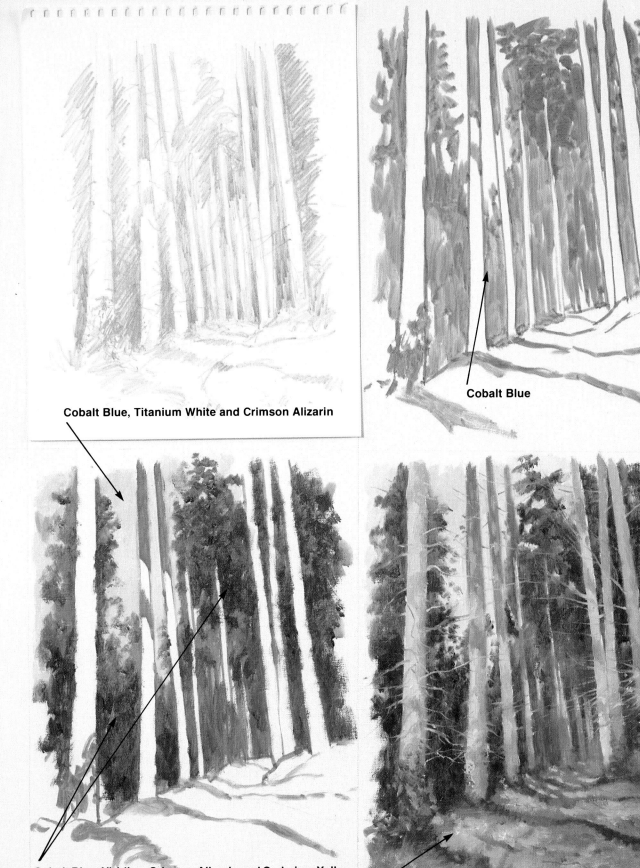

Cobalt Blue, Titanium White and Crimson Alizarin

Cobalt Blue

Cobalt Blue, Viridian, Crimson Alizarin and Cadmium Yellow

Titanium White, Viridian, Cadmium Yellow and Crimson Alizarin

Fig. 44

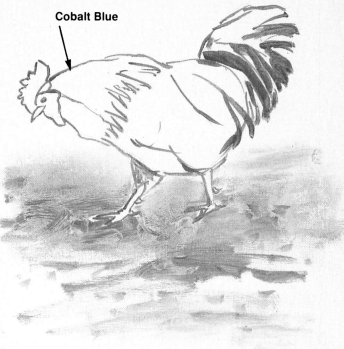

Cobalt Blue

Cadmium Yellow and Cadmium Red

Cobalt Blue, Viridian, a little Cadmium Red and Titanium White

Cadmium Red, Crimson Alizarin, Cadmium Yellow, Cobalt Blue and Titanium White

OIL SKETCHING AND PAINTING OUTDOORS

When you feel confident painting indoors, then it's time that you took your paints outside and worked at nature first hand. Every painting you do from nature adds more information into your 'store cupboard', your brain, which will make your next painting easier and, more important, you will find it easier the next time you work indoors from a pencil sketch.

I have called this chapter 'Oil Sketching and Painting Outdoors'. Let me make it clear that a sketch can be accepted as a finished painting and hung in any gallery, just as a large detailed painting can. A painting is a statement that you have made in paint on canvas and the size or the amount of time or work you have put into it doesn't matter. However, when an artist sets out to do a sketch outdoors, usually the prime objective is to get information to use at a later date in the studio for painting a larger or more finished picture; whereas a painting done outdoors is simply a picture that you start and know you will finish as a painting in its own right.

There is no size barrier for a sketch; it can be as small or as large as you want. However, an oil sketch (used for information) has got one major drawback and that is the amount of detail that cannot be painted in. This, of course, is because of the very nature of the paint. For instance, it is very difficult to paint thin lines over wet paint. The answer is to go for the atmosphere of the scene, 'the feel of it'. Make sure you get the tones of objects correct in relation to other objects. Remember that it helps if you half-close your eyes to do this. Look for shapes rather than detail. If you feel you will not be able to carry the detail in your head, then make pencil notes in your sketch book, either written or drawn ones.

When you are outdoors, the conditions are very different from indoors, where you have control of the light, heating, comfort – in fact all the elements that you work in. Unfortunately, most of them are not under your control outside. Here are some very important ground rules. Make sure you take enough clothing to keep warm – you can always take some off, but you can't put any extra on if you don't have it with you. Take a comfortable fold-up seat on which to work. You must try to be as comfortable working outside as when you are inside. Don't have too much equipment to carry or, when you find your spot, all you'll be fit for is a long rest, not painting! Don't spend all morning looking for a 'better' place to paint (we all do it, including me), or your painting time will disappear. The answer to this age-old problem is to

paint the *first scene* that inspires you and not to think that there must be a better one round the corner, and then, when you have walked round the corner, to think there may be a better one still round the next corner, and on and on it can go. As soon as you are inspired – paint! If possible, check that the subject you are going to paint will stay there! If you are painting a tractor, a boat or any working object, workmen can move it. Also make sure you are not obstructing any normal workday duties – or you will be moved on. If you are not sure, then ask someone.

If you are going by car you can carry a lot of equipment, more than you need, but it gives you a base containing extra equipment from which to draw if you forget or run out of any, or spill your bottle of turps!

Remember the country code: close all gates after you. If a gate is open, leave it open. Finally, if you are in the countryside and you want to paint in a field where there are cows, try another field. They can be too inquisitive and spoil a happy painting trip!

Sketching Exercises

I drew **figs. 45–48** and **51–54** the same size as they are reproduced here. This gives you an indication of the formation of the brush strokes. I drew **figs. 49** and **50** 13 × 18 cm (5 × 7 in). I have done them all in two stages to show how I started them, and they are small to show how a small oil painting can be as exciting to do as a large one.

St Michael's Mount This exercise (**figs. 45** and **46**) was worked on oil sketching paper (smooth). Paint over the paper first with a turps and Cobalt Blue wash. When it is dry, draw in the main areas with an HB pencil. Use your Series B48 No. 4 brush for the whole of the picture, except the boat and men; for these use your Rigger No. 1. The bright sunlight in the clouds over the sea was done with thick paint when everything else was finished. Notice how I left some of the Cobalt Blue underpainting showing through. Colours: Cobalt Blue, Crimson Alizarin and Yellow Ochre.

The White Farm This picture (**figs. 47** and **48**) was worked on an oil painting board and first painted over with a turps and Raw Umber wash. Draw in the picture with an HB pencil and then, with your Series B48 No. 1 brush, use a turps and Cobalt Blue mix to draw over the pencil and fill in the dark tonal areas. Then

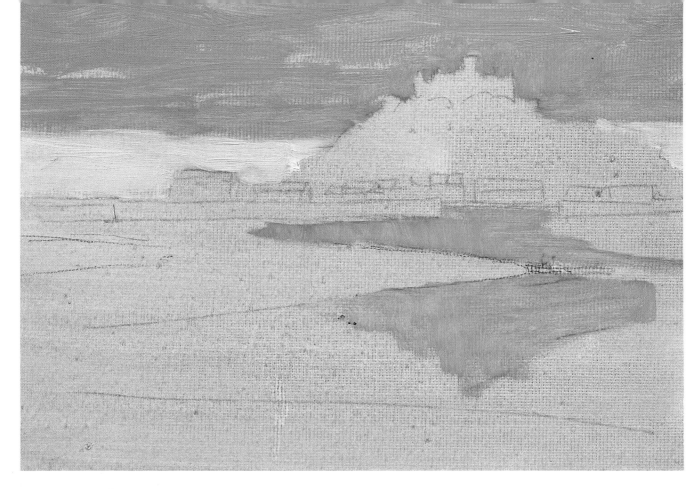

Fig. 45 (*above*) St Michael's Mount, first stage **Fig. 46** (*below*) Finished stage

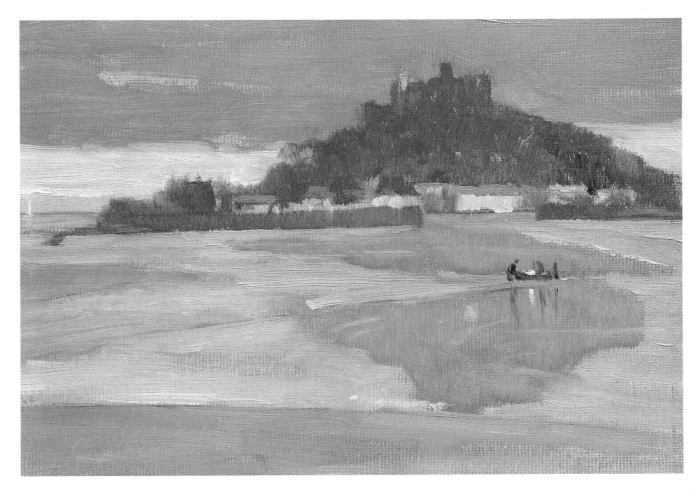

Fig. 47 (*above*) The White Farm, first stage **Fig. 48** (*below*) Finished stage

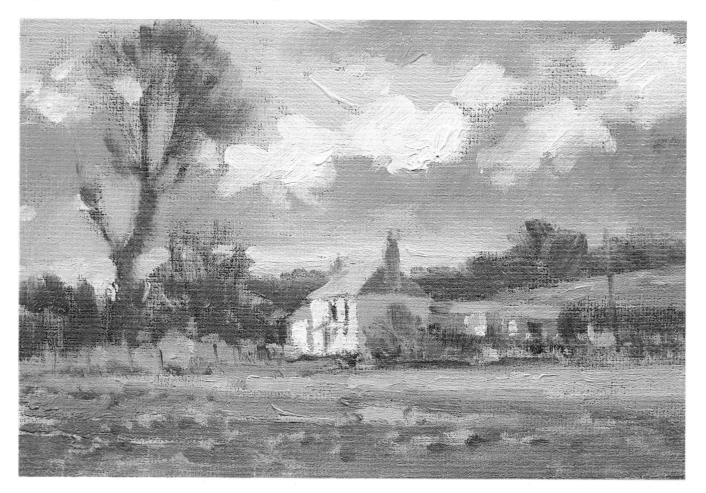

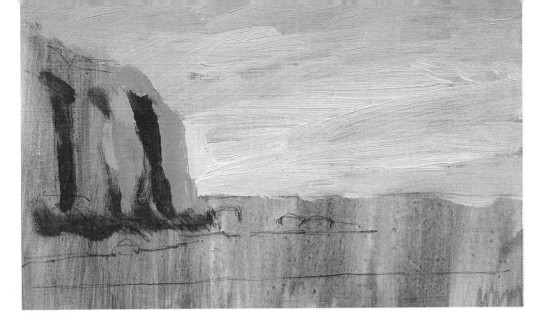

Fig. 49 (*above*) Beach, first stage Fig. 50 (*below*) Finished stage

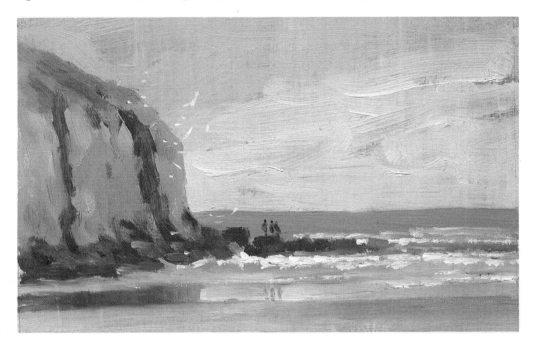

paint the sky with your Series B48 No. 4 brush. Next, with your Series B48 No. 2 brush, paint over the dark trees in the middle distance and then, with your Series B48 No. 4 brush very dry, paint the feathery branches of the large tree. Now, with your No. 2 brush again, paint in the house and fields. Use thick paint for the 'white' clouds and sunlit side of the farmhouse. Colours: Cobalt Blue, Yellow Ochre, Cadmium Yellow, Crimson Alizarin and Titanium White.

Beach For this exercise (**figs. 49** and **50**), I painted one coat of white emulsion paint over a sheet of car-tridge drawing paper. When this was dry, I painted a wash of Acrylic colour, Raw Umber and Crimson Alizarin over the emulsion paint. Remember, you can paint oil over acylic paint – when it is dry – but never acrylic over oil paint. Draw in the scene with your HB pencil, then paint in the sky with your Series B48 No. 4

brush and use this brush for all the sketch except for the seagulls and figures. For these use your Rigger No. 1. Don't get fussy with the rocks, keep them simple. Thick Titanium White and a little Cadmium Yellow were used to get the breaking waves and surf under the rocks. What is very important with this sketch is that if it were not for the three people on the rocks, there would be no reference to scale in the picture. The cliffs could be 4.5 metres (15 feet) or 152 metres (500 feet) high. Scale is very important in any painting, so that we can relate to the scene. Colours: Cobalt Blue, Yellow Ochre, Cadmium Yellow, Crimson Alizarin and Titanium White.

Two Boats I used oil-primed canvas for this sketch (**figs. 51** and **52**). Draw in with pencil first and then, using your Rigger No. 1 brush, paint in the boats with

Fig. 51 (*above*) Two Boats, first stage **Fig. 52** (*below*) Finished stage

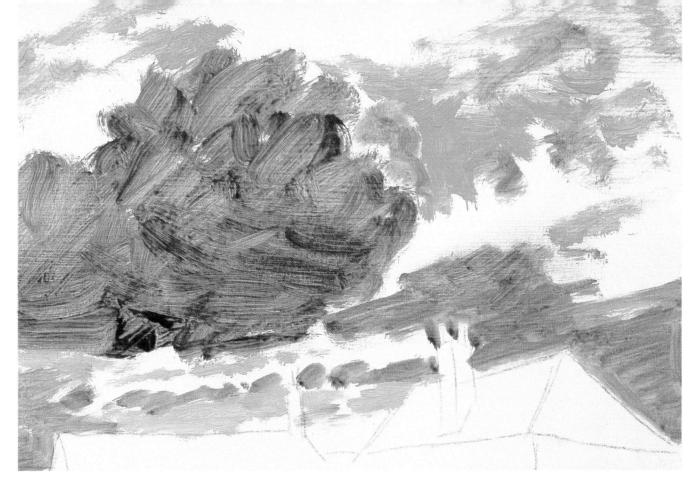

Fig. 53 (*above*) Sky, first stage **Fig. 54** (*below*) Finished stage

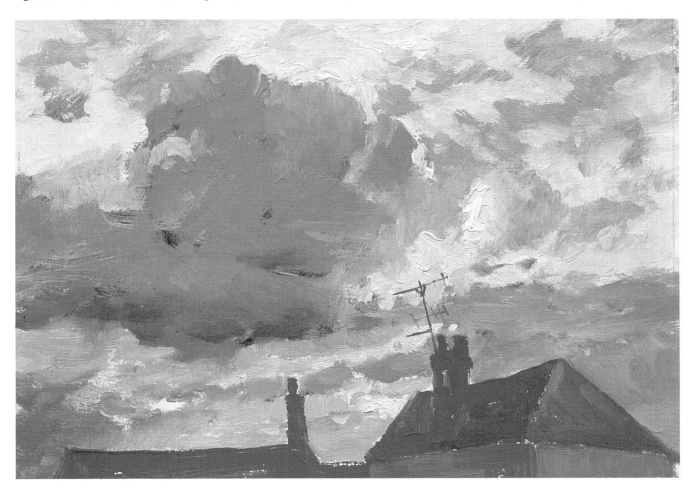

Fig. 55 Sky studies

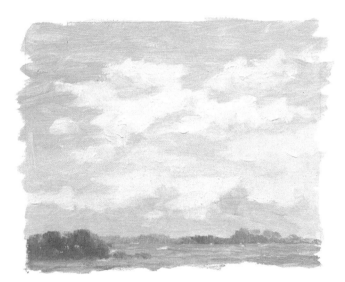

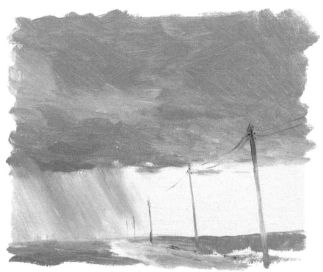

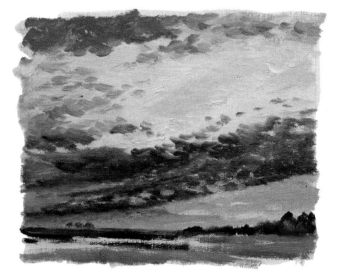

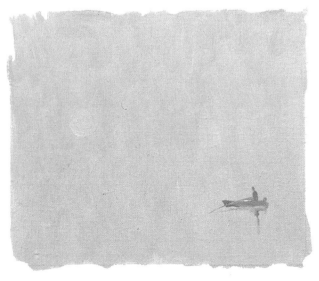

turps and Cobalt Blue. Next, using your Series B48 No. 2 brush and the same colours, paint in the dark areas. With your Series B48 No. 4 brush, work on the harbour wall, then paint in the reflections. Now, using your No. 2 brush again, work on the boats but don't get over-fussy with them. Next, paint the harbour quayside and finally, using thicker paint, work in the sunlit water. Colours: Cobalt Blue, Viridian, Crimson Alizarin, Yellow Ochre, Cadmium Yellow and Titanium White.

Sky The sky is the most important part of a landscape painting. It sets the mood of the scene, therefore it is important to practise and to learn to paint it well. Do try to copy from life as much as possible. Clouds move, and as you start to paint your subject will change shape or even disappear. The secret is to sit and watch the sky and the clouds for a while, until you have observed the movement and pattern they make. Then, as you see a section you like, start to sketch it quickly. As it moves you will know the pattern and formation of the overall sky from your observation and so will be able to ad-lib as your model moves on. Some sky formations can last long enough to paint them before they change, but don't just practise on these – try the difficult ones as well! Always put some form of land object – distant hills, tops of trees or, as in **fig. 54**, rooftops – to give scale and the angle of direction that you are looking at the sky.

When you are working outside, mix your main colours first before you start to paint, or your clouds will have moved on before you are ready!

The sky in **figs. 53** and **54** was painted on emulsion-(one coat) primed cartridge paper, and the colours used were Cobalt Blue, Yellow Ochre, Crimson Alizarin and Titanium White.

Before you start working from life, copy the six sky sketches I have done (**fig. 55**). I did each painting 18 × 14 cm (7 × 5⅝ in) on canvas. By copying these first it will give you more confidence to work at a moving sky from life. These are the colours that I used, but not necessarily all on one painting: Cobalt Blue, Cadmium Red, Crimson Alizarin, Yellow Ochre, Cadmium Yellow and Titanium White.

Snow Landscape **Fig. 56** was painted on canvas with a turps, Cadmium Yellow and Crimson Alizarin wash, picture size 18 × 20 cm (7 × 8 in). When the background wash is dry, paint in the trees and foreground shadows with your Series B48 No. 1 brush. Now paint in the sky around the two main trees, and then the background trees and field. When you paint the sky, don't go over the underpainting drawing of the middle distance trees or you will have difficulty in painting your dark trees on top. You can always add sky colour into your trees later to help make the shapes. Next,

Fig. 56 Snow Landscape

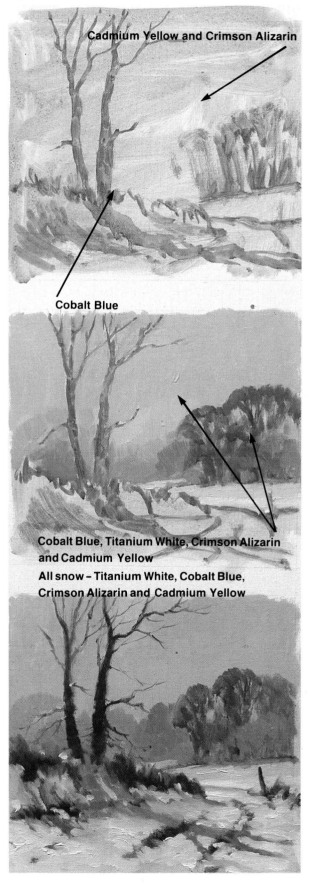

Cadmium Yellow and Crimson Alizarin

Cobalt Blue

Cobalt Blue, Titanium White, Crimson Alizarin and Cadmium Yellow

All snow – Titanium White, Cobalt Blue, Crimson Alizarin and Cadmium Yellow

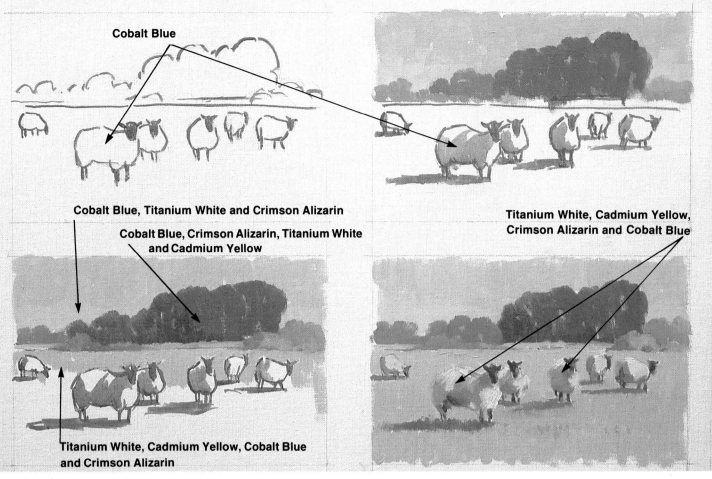

Cobalt Blue

Cobalt Blue, Titanium White and Crimson Alizarin

Cobalt Blue, Crimson Alizarin, Titanium White and Cadmium Yellow

Titanium White, Cadmium Yellow, Crimson Alizarin and Cobalt Blue

Titanium White, Cadmium Yellow, Cobalt Blue and Crimson Alizarin

Fig. 57 (*above*) Sheep **Fig. 58** (*below*) Country lane, Metcombe

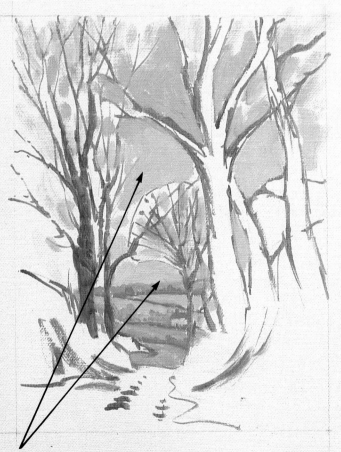

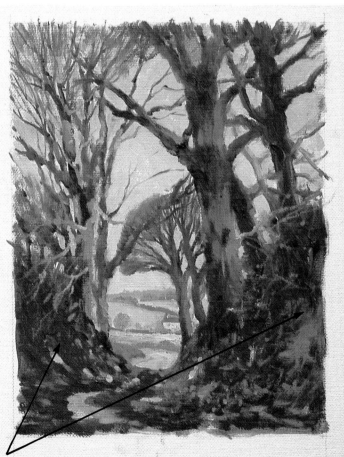

Add to Titanium White: Cobalt Blue, Crimson Alizarin and Cadmium Yellow

Cobalt Blue, Crimson Alizarin, Cadmium Yellow and Titanium White

paint in the two main trees with Cobalt Blue, Crimson Alizarin, Cadmium Yellow and a little Titanium White, and use your Dalon Series D99 No. 2 brush for the small branches. Put in the hedge, shadows and cart tracks using the same colours, in different mixes, as for the two trees and, finally, paint in the foreground snow, using thick paint.

Sheep You have the same problem with animals as you do with the sky – they will not keep still! When I paint animals, I usually start with one, get halfway through and it moves on. I then look for another in roughly the same position and carry on, or even improvise the finish. You can only become proficient at animal subjects by sketching and getting to know them, through constant work and observation. A camera can help, because you can study your own photos (slides) on a large screen and see how the animals are formed. Until you are confident, keep them at a distance in your painting, where you will not have to suggest too much detail. In **fig. 57** the sheep are not detailed; I have only painted their overall shape and character, and in fact their heads are just dark shapes. They were painted on oil-primed canvas 11 × 18 cm ($4\frac{1}{2}$ × 7 in). Colours: Cobalt Blue, Crimson Alizarin, Cadmium Yellow and Titanium White.

Country Lane, Metcombe This view (**fig. 58**) has always excited me. I walk past it many times and its fascination is in the very dark shadows forming an archway with the trees and a strong sunlit landscape beyond. I painted this on an oil-primed canvas panel, picture size 23.5 × 18.4 cm ($9\frac{1}{4}$ × $7\frac{1}{4}$ in). After drawing, paint in the sky and distant landscape. The brightness of the landscape will not become apparent until you have painted in the dark trees (light against dark). At first I painted all the trees dark, but found it overpowering, therefore I suggested sunlight on the two trees on the left. This made a tremendous difference; it seemed to give life and atmosphere to the picture. I used my Series B48 Nos. 2 and 4 brushes and my Dalon Series D99 No. 2 brush for the small branches.

Rye, Sussex I painted this exercise (**fig. 59**) on oil-primed canvas, picture size 18 × 20 cm (7 × 8 in). Use your Rigger No. 1 to draw in with and then paint in the sky; using your Series B48 No. 4 brush, work thick paint for the clouds. Now paint in the main shadow areas of the town. Apart from the sky, use your Series B48 No. 2 brush for all the picture, except the chimney-pots and suggestion of tree trunks, for which use your Rigger No. 1. Paint the foreground thinly, as this is not so important as the skyline which is the inspiration and composition for this picture. Colours: Cobalt Blue, Crimson Alizarin, Cadmium Yellow and Titanium White.

Fig. 59 Rye, Sussex

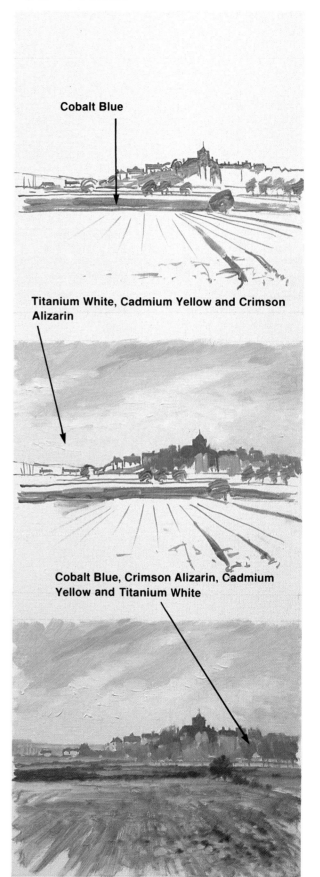

Cobalt Blue

Titanium White, Cadmium Yellow and Crimson Alizarin

Cobalt Blue, Crimson Alizarin, Cadmium Yellow and Titanium White

WORKING FROM AN OIL SKETCH

It is interesting to see a pencil sketch, an oil sketch and the finished painting reproduced together, all approximately the same size. Normally you only see them in their true life sizes. In this case the pencil sketch (**fig. 60**) was done on an A4 sketch pad, the oil sketch (**fig. 61**), worked on oil sketching paper, was painted 13 × 18 cm (5 × 7 in), and the finished painting (**fig. 62**) was done on oil-primed canvas, 41 × 61 cm (16 × 24 in).

When you go outside to make a sketch from which to work a larger painting at home, what you put into the sketch is really up to you as it is you who will have to copy from it and therefore you will know what information you require. But, as I said earlier, a sketch painted in oil has its limitations for showing detail (small brush work) information. There is a limit to how much detail can be worked (a) over wet paint (b) working on a small scale. However, the one great advantage that oil paint has on a small scale is to enable you to capture the atmosphere of the scene and this is what you must aim for. Any detail work can be recorded either by making notes, or by doing a pencil sketch and putting in the detail that you require. In a complicated scene this could be two pages of careful drawings of the various objects which you will want to paint in detail in the finished picture.

When you start work on the painting at home, use the mood (atmosphere) you created in the sketch as your main inspiration. If your painting changes from your sketch while you are working, to whatever degree, don't worry. Remember that you are only using the sketch as your source of inspiration; let your creative instincts have full rein when you paint the final work. Naturally, if you wanted to paint a particular scene and represent it faithfully, then you must work closely to your sketch and notes and hold down your creative wanderings! As I said earlier, you can take a photograph to add to your atmosphere sketch, and a pencil sketch to give you a third source for detail information.

Fig. 60 Pencil sketch

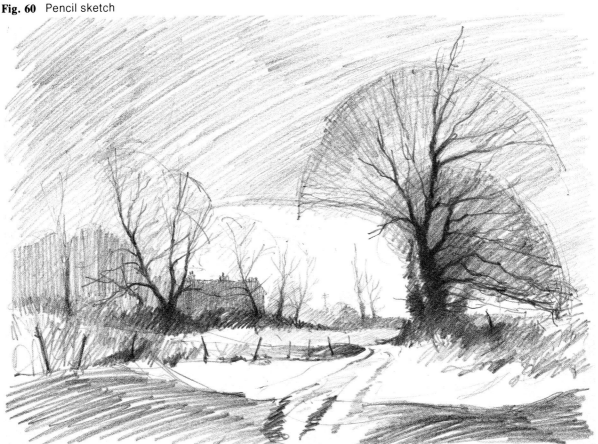

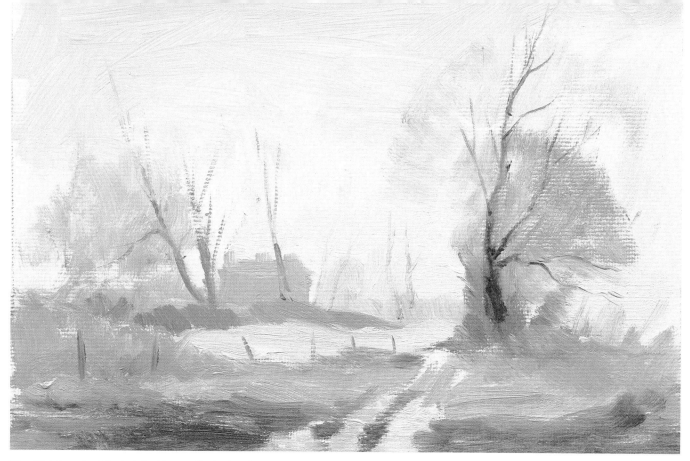

Fig. 61 (*above*) Oil sketch **Fig. 62** (*below*) Finished painting

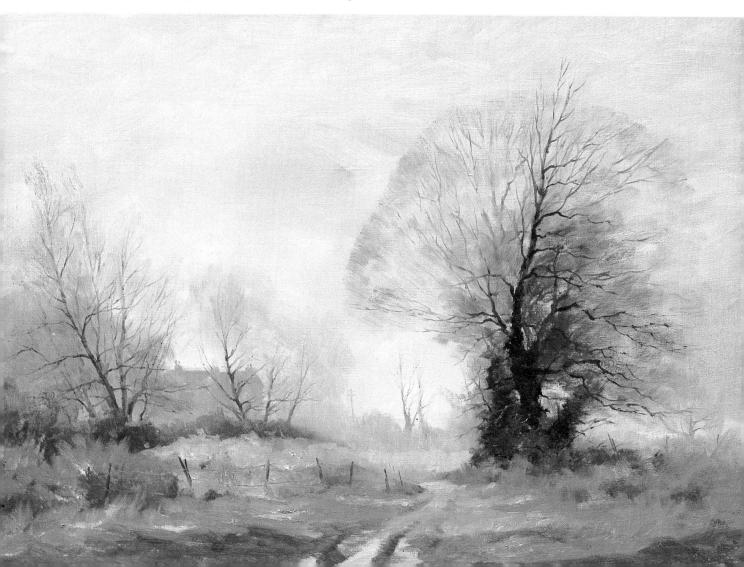

Exercise one
SUMMER LANDSCAPE

In this exercise and the ones to follow, it is important to remember when mixing your colours to start with the one I have listed first, then add to it the other colours, usually in smaller amounts. The first colour of your mix should be the main one. For instance, if you wanted to mix a pale blue, you would start with white and mix small amounts of blue into it until the required 'pale blue' is reached.

In these exercises I have tried to give you a detailed account of the way I have worked. Naturally I can't give you a brush stroke by brush stroke account as there is insufficient space in the book, but I have explained the important features of each stage. As I completed each stage it was photographed. This enables you to see how the painting develops until it is finished. The actual size of each painting is indicated next to the finished stage, as it is important for you to know the scale to which to work. The close-up illustrations are reproduced the same size as I painted them, so you can see some of the brush strokes. I have also illustrated the method I used for certain parts of the paintings, the arrows indicating the direction of the brush strokes and the movement of the brush (see page 17).

Incidentally, the paintings in the exercises were done in one sitting, I didn't wait for areas to dry.

I have painted these subjects in my own style which has evolved over the years. The way I paint in this book is the way I work; I haven't made the paintings

work for the book. *This is very important.* We all have a creative style of our own and this will emerge naturally. *Whatever you do, let your own style come to the fore.*

Summer is a wonderful season for painting landscapes. Because the trees are covered with leaves and the flowers are in bloom, everywhere seems cosy and happy. The colours are soft and warm, and most of the hard shapes of winter have melted away. However, when I am out working in the autumn or winter, I enjoy it just as much as I do the summer! How invaluable it is that we can adapt to our surroundings. The picture I have painted for this exercise was sketched on a very warm summer's day a few miles from where I live, and I have used the sketch to work from in my studio. Don't try to copy every detail or your picture will become 'lifeless'. See **fig. 63** for the colours used in this exercise. Good luck!

First stage I used oil-primed canvas and painted it over with a turpsy wash of Cadmium Yellow mixed with Crimson Alizarin. When your turpsy wash is dry, start by drawing in the main features of the picture with an HB pencil and then, using your Rigger No. 1 with a mix of Cobalt Blue and Crimson Alizarin mixed with turps, draw over the pencil.

Second stage For the whole of this stage use your Series B48 No. 2 brush. Incidentally, if the 'drawing in' paint is still wet, don't worry. It can mix with the underpainting colour. Starting from the top, using the same colours as for the drawing in the first stage, paint in the picture to arrive at its tonal values. This means that you will need dark and light colour. Do not use white to lighten the colour, use turps. For those of you who use watercolour, it is just the same as painting in watercolour. Notice how the brush strokes help to form the shape of objects. As I said earlier, your brush strokes should always follow the direction that objects grow or go. For instance, trees grow upwards and therefore brush strokes should work up trees. Look at the large dark trees, even in this stage they look like growing trees in full leaf. Can you imagine what they would look like if they had been painted in horizontal brush strokes? Movement is also depicted by your brush stroke. For instance, if you are painting clouds and they are travelling from left to right, then let your brush strokes work from left to right. Use this method as much as possible on your paintings, from the largest mountain to the smallest blade of grass – it will help

Fig. 63 Colours used for this exercise

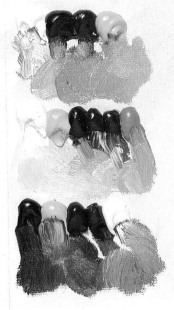

MID/DISTANT TREES
Titanium White
Cobalt Blue
Crimson Alizarin
Cadmium Yellow

FIELDS
Titanium White
Cadmium Yellow
Cobalt Blue
Crimson Alizarin
Viridian
Yellow Ochre

TREES
Cobalt Blue
Cadmium Yellow
Crimson Alizarin
Viridian
Titanium White

Fig. 64 First stage

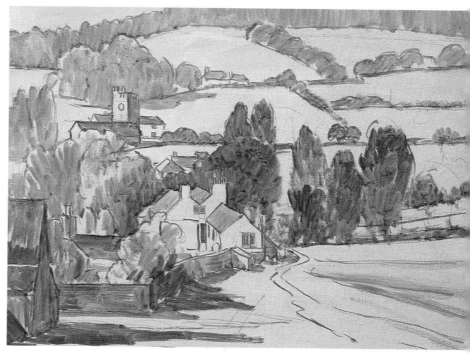

Fig. 65 Second stage

Fig. 66 Third stage

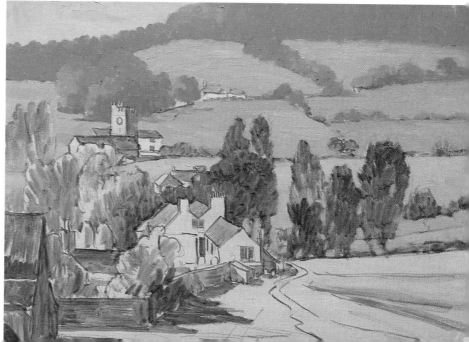

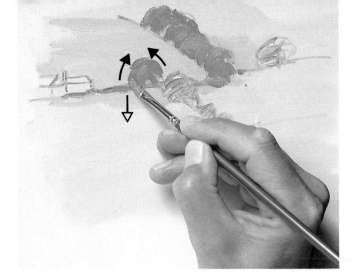

Fig. 67

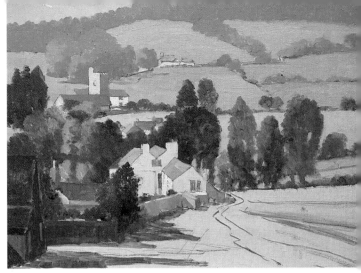

Fig. 68 Fourth stage

to make your paintings come 'alive'.

Up to now I have always suggested you draw with pencil, then with paint, and then add your underpainting. It is at this point that you are ready to paint. One reason I have told you to draw your picture twice, i.e. pencil and paint, has been to give you confidence. But once you are confident, you can work directly with your colours onto a surface without underpainting or drawing. Or, of course, you can use only paint to draw in with, or work straight in with your underpainting with no drawing. The choice is yours.

Third stage Throughout this stage use your Series B48 No. 4 brush. First, paint in the sky, using a mix of Titanium White, Cobalt Blue and Crimson Alizarin. Next, paint in the long line of trees in the distance, using a mix of Titanium White, Cobalt Blue, Crimson Alizarin and a little Cadmium Yellow. Remember the direction of your brush strokes. Now paint in the two top fields, using Titanium White, Cadmium Yellow, a little Cobalt Blue and Crimson Alizarin. Paint in the trees behind the church, and the ones that separate the top fields next, using the same colour as the fields, but adding a little Viridian to your mix. Now work the fields to the left and right of the church. Add Yellow Ochre to your field colour for the field on the extreme right. For the field behind the main dark trees add Viridian and more Titanium White.

Fourth stage With your Series B48 No. 2 brush, start by painting in the shadows and roofs of the church and house to the right. Use Titanium White, Cobalt Blue, Crimson Alizarin and a touch of Yellow Ochre. Using the same colour, but a little warmer (more red), paint in the dark roofs behind the dark trees. Using the same brush and a mix of Titanium White, Cobalt Blue, Crimson Alizarin and a touch of Yellow Ochre, paint the roofs of the large white house. With the same colour but a little cooler (add blue), paint the light colour of the roofs behind the trees. Now paint the sunlit side of the church with a mix of Titanium White, Yellow Ochre and a touch of Crimson Alizarin.

Add a little more Titanium White and paint in the sunny side of the house next to the church. With the same colour, paint in the walls of the large white house. The main body of trees comes next. Mix various colours and tones of green, using Cobalt Blue, Cadmium Yellow, Crimson Alizarin and Viridian, adding Titanium White where you want the green to be lighter, then, using your Series B48 No. 4 brush, follow my painting and paint in the trees. Now paint the roofs and chimney of the foreground buildings using Cobalt Blue, Crimson Alizarin, Yellow Ochre and a touch of Titanium White. Use the same colours for the walls in shadow. For the wall leading to the large white house and the white wall of the left-hand building, use Titanium White mixed with Cobalt Blue, Crimson Alizarin and a touch of Yellow Ochre. Now, with your Series B48 No. 2 brush, paint in the small tree in the foreground with your tree colours, which should still be wet on your palette.

Finished stage Start by painting the foreground field, using your Series B48 No. 4 brush with a mix of Titanium White, Viridian, Cadmium Yellow and Crimson Alizarin. When you paint the field, don't paint over the shadows. Notice how the brush strokes on the right of the path go in perspective towards the bottom of the field. This helps to give direction and, above all, helps to make the field look flat. Next work the path, using Titanium White, Yellow Ochre, Crimson Alizarin, and some of your field colour.

Now you can paint in the shadows on the field with a mix of Titanium White, Cobalt Blue, Crimson Alizarin and a touch of Yellow Ochre.

At this stage leave your painting for a break and come back with a fresh eye and see what detail it needs to complete it. On my painting I put in the church clock, a shadow on the house wall next to the church, a cool grey on the distant farm houses, and a small tree in front of the large white house with its shadow cast onto the wall of the house. Then I added chimney pots and accents where necessary, and finally painted in some birds over the trees.

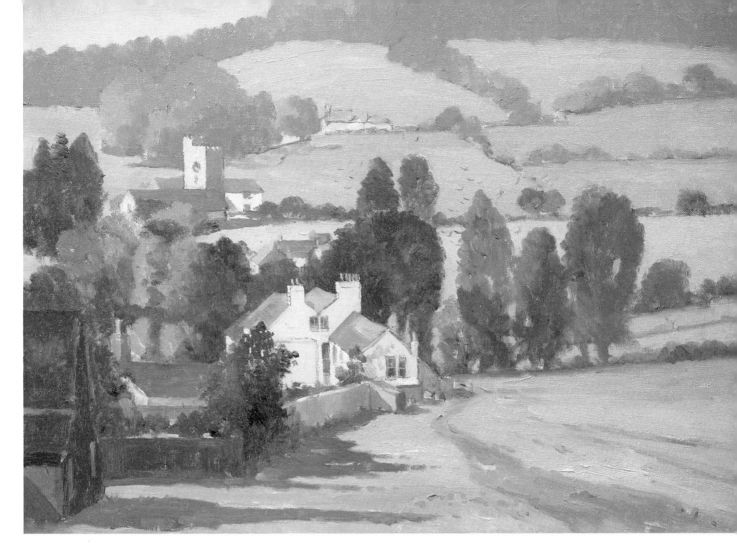

Fig. 69 (*above*) Finished stage, 30×41 cm (12×16 in) **Fig. 70** (*below*) Detail from finished stage

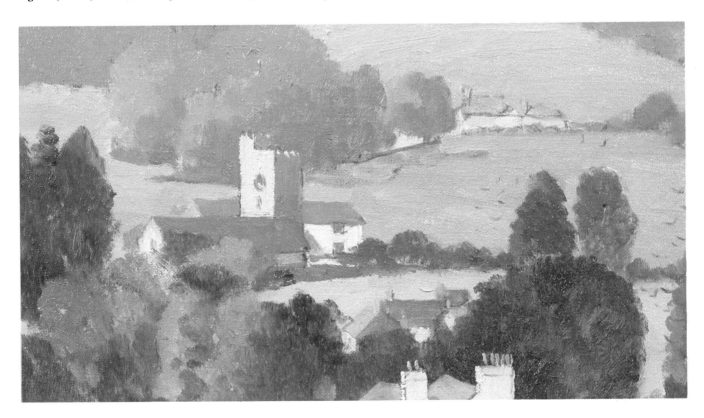

Exercise two
FLOWERS

Flower painting is very much like still life painting. If you are not capable of working outside, then these can always be painted indoors. The subject can be created to suit your ability, or creative mood. For instance, if you are a beginner you can put one simple bloom on a table and paint it, or if you are brimming over with confidence you can fill a large vase with all the flowers you can find in the garden, creating a painting subject full of delicate life and colour. You can, of course, paint direct, working outside and painting the flowers in their natural setting.

One word of advice: throughout the book I have suggested using few colours, in fact mainly the three primary colours – red, yellow and blue. When painting flowers, however, you will find it easier and get better results if you add more colours to your palette. These will be decided by the flowers you are painting. If you are painting a flower predominantly lemon yellow, then use a Lemon Yellow paint as your main colour; or if a flower were purple, then buy a purple paint and use it as the main colour for *that* flower, and so on. For this exercise I have chosen Dog Daisies, as these can be painted with the colours that we are using throughout the book (see **fig. 71**).

First stage I painted these flowers on an oil-primed canvas over which I put a turpsy wash of Yellow Ochre

Fig. 71 Colours used for this exercise

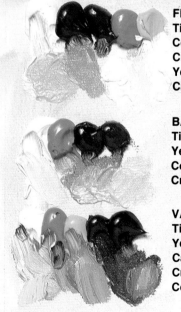

FLOWERS
Titanium White
Cobalt Blue
Crimson Alizarin
Yellow Ochre
Cadmium Yellow

BACKGROUND
Titanium White
Yellow Ochre
Cobalt Blue
Crimson Alizarin

VASE
Titanium White
Yellow Ochre
Cadmium Yellow
Crimson Alizarin
Cobalt Blue

before I started the drawing. I did this with a rag over my finger. When this is dry, draw first with an HB pencil, then use your Series 43 No. 4 sable and draw over the pencil, using a mix of Cobalt Blue and a little Crimson Alizarin. If you look closely at the first stage picture you will see on the right hand side that I changed the flower positions from the pencil drawing when I painted them in with the sable brush. I have pointed this out because at the very beginning – drawing stage – a picture develops and is changing (sometimes very subtly, at other times radically) throughout its creation until it is finished. So never be afraid if your picture is changing direction during its progression, but make sure any change is for the better!

Second stage Use your Series B48 No. 4 brush for the underpainting of the background and vase (I used my fingers in places). Use a turpsy mix of Yellow Ochre, Crimson Alizarin and Cobalt Blue. When you are painting the background don't paint over the flowers. Then, with your Series B48 No. 1 brush, using a mix of Cobalt Blue and Crimson Alizarin, paint in the shadows on the flowers.

Third stage Now paint in the background with your Series B48 No. 4 brush, using a mix of Titanium White, Yellow Ochre, Crimson Alizarin and a little Cobalt Blue. Don't worry if some of the underpainting is still wet; let it mix with your paint as you work. Work up to the flower petals. If your background colour goes over onto the petals, it doesn't matter, because you will be painting over the petals to give them their colour and final shape later. Next, paint in the shadows on the flowers; use your Series B48 No. 1 brush and work each brush stroke to represent a petal. Use a mixture of Titanium White, Cobalt Blue, Crimson Alizarin and a touch of Yellow Ochre. With the same brush, using Titanium White, a little touch of Crimson Alizarin and Cadmium Yellow, paint in the middle tones of the petals. While you are doing this, with the same brush pick up some of the background colour that is on your palette and work it into the petals. This reflects the background colour into the white of the flowers and helps to give a uniformity of colour to the picture. Now put in the flower centres, using Titanium White, Cadmium Yellow and Crimson Alizarin. For the shadow side add a little Cobalt Blue. Finally, on the flowers, paint in the lightest petals using Titanium White and a touch of Cadmium Yellow. Notice how the bottom right-hand flower has a very 'white' petal

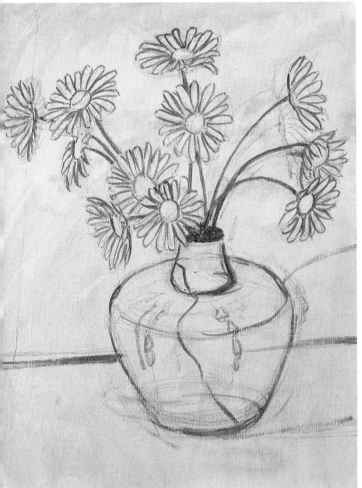

Fig. 72 First stage

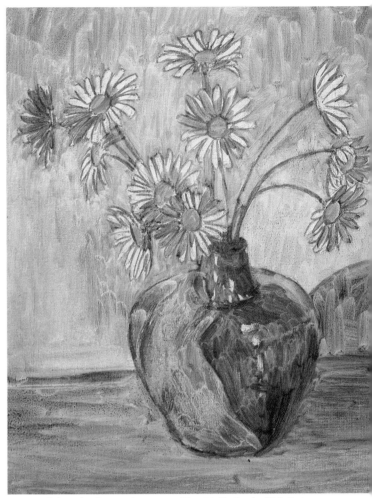

Fig. 73 (*above*) Second stage **Fig. 74** (*below*) Third stage

that has caught the light. This works well because the light petal is against dark background and dark petals. Remember light against dark shows form and it can also create the illusion of an area being lighter, or darker, in a picture. Finally, with your Series 43 No. 4 sable, paint in the stems, using Cobalt Blue, Crimson Alizarin, Cadmium Yellow and a little Titanium White.

During this stage the flowers were changing position in the vase quite alarmingly. Some had drooped well over the vase, some had opened more and others had moved over and covered other blooms. I am afraid that when you are working from nature, whether it is a large mountain scene or indoors from a vase of flowers, nature is always on the move and we have to cope with it.

Finished stage Use your Series B48 No. 4 brush to work on the light-coloured area of the vase. Mix Titanium White, Yellow Ochre, Cadmium Yellow, Crimson Alizarin and Cobalt Blue. For the dark colour on the vase, mix Cobalt Blue, Crimson Alizarin,

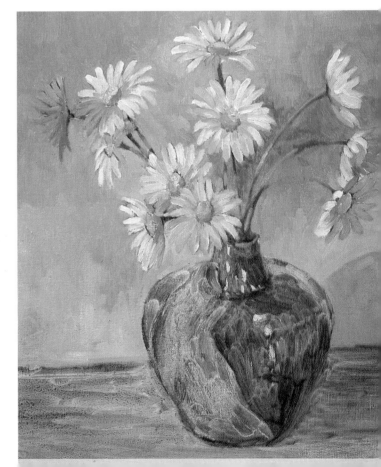

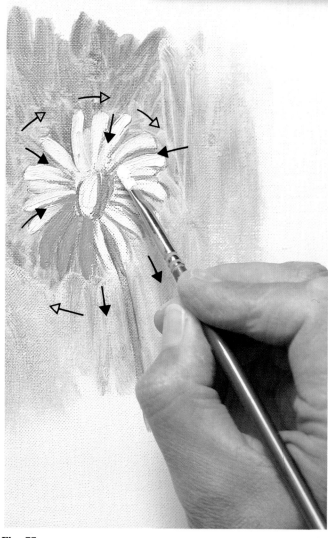

Figs. 75 (*above*) **and 76** (*below*) Details from finished stage **Fig. 77**

Yellow Ochre and a little Titanium White. Let your brush strokes follow the shape of the vase; this will help to make it look more three-dimensional. Then, using the same colours, work on the table, with your brush strokes painted horizontally. Work some cool highlights on the vase, using Titanium White, Cobalt Blue and a little Crimson Alizarin. Notice the highlight on the bottom right-hand side of the base. This is a reflected light and it helps to make the vase appear round. On the light brown side of the vase also paint some warm highlights by adding Cadmium Yellow to Titanium White. With your Series 43 No. 4 sable, add some highlights to the stems of the flowers and the small dried leaves on the stems. Finally, look at *your* picture and decide where you may need some dark or light accents to help the painting. Although you have copied my painting, your picture will have its own little areas of beauty and those little happy accidents that give a painting a magic quality, and by now I hope your own style will be showing itself.

Fig. 78 Finished stage, 41×30 cm (16×12 in)

Exercise three
BOATS

Last summer I did some painting in Scotland, the first time I had ever been there. It's an exciting place for the painter with its beautiful mountains and lochs. One thing I did notice was how cool the light was compared to where I live in Devon. Compare the finished picture (**fig. 87**) with Summer Landscape, Exercise One (**fig. 69**), which is warm and mellow, where this one is cool, crisp and clear. I painted a watercolour 35.6 × 46 cm (14 × 18 in) (**fig. 85**) of this scene sitting on the quay (I had to rush into the car twice during the painting because of two heavy rain showers), and I have used that painting in the studio to help me work the oil painting for this exercise. I have made it the final exercise, because I feel it is the most ambitious painting in the book. There is a lot of 'drawing', and that crisp, clear atmosphere to capture. But by now, if you have worked hard you should be capable of doing this painting. See **fig. 79** for the colours used. Good luck!

First stage I painted this on oil-primed canvas. Draw in first with an HB pencil. Then, using your Rigger No. 1 brush with a mixture of Cobalt Blue and Crimson Alizarin, work over the pencil.

Second stage Now the underpainting. Use Cobalt Blue and Crimson Alizarin as usual, mixed with plenty

Fig. 79 Colours used for this exercise

SKY/WATER
Titanium White
Cobalt Blue
Crimson Alizarin
Yellow Ochre
Cadmium Yellow

MOUNTAINS
Titanium White
Cobalt Blue
Crimson Alizarin
Yellow Ochre
Viridian
Cadmium Yellow

TREES
Cobalt Blue
Crimson Alizarin
Cadmium Yellow
Viridian
Titanium White

of turps. Start at the top of the canvas and, with a rag over your finger, paint in the sky, mountains and trees. Then use your Series B48 No. 2 brush and work the tonal values of the buildings and boats. Use the rag to paint in the foreground quay.

Third stage Using your Series B48 No. 4 brush, start working on the sky. Paint in the blue areas first, starting at the top and working down, using Titanium White, Cobalt Blue and Crimson Alizarin. Then work the light-coloured clouds, using Titanium White, Yellow Ochre and a touch of Crimson Alizarin, and paint over the mountain tops on the right. Add some Cobalt Blue to your mix and paint in the dark cloud hanging over the mountain. Now paint the mountains, using Titanium White, Cobalt Blue, Crimson Alizarin and Yellow Ochre. Start at the left and work to the right. Paint into the clouds that are now over the mountains; don't paint over the two green 'fields' on the mountain or behind the large trees.

Then, with a mixture of Titanium White, Viridian and Cadmium Yellow, paint in the two green 'fields' on the mountain. Now merge the cloud back over the mountain into the wet 'mountain paint'. This will help to soften the edges of the clouds and also give them the appearance of being *over* the mountain. Now, with your Series B48 No. 1 brush, using Cobalt Blue, Crimson Alizarin, a little Cadmium Yellow, a little Viridian and a little Titanium White, paint in the distant trees and the large group behind the single white house.

Fourth stage Start by painting the sunlit field in the distance. Use your Series B48 No. 1 brush with a mix of Titanium White and a little Viridian and Cadmium Yellow. Darken the field to the left and in front (behind the boats) by adding a little Cobalt Blue. Now paint in the shadow side of the white house with a little touch of 'mountain colour' (which should still be on your palette) and Titanium White, then paint the sunlit side with Titanium White with a dash of Crimson Alizarin. Next paint in the dark lock gates with Cobalt Blue, Crimson Alizarin and Yellow Ochre. With your field colour, adding a little Crimson Alizarin, paint in the bank to the right of the lock gates and then, using your lock-gates colour, the dark edge to the bank. Now paint in the houses on the left; for the sunlit roofs use Titanium White, Cobalt Blue, and a touch of Crimson Alizarin and Yellow Ochre, and for the ones in shadow use the same colours but less

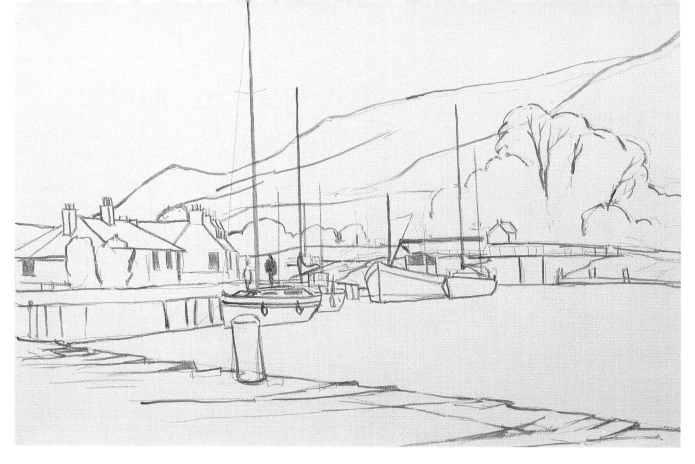

Fig. 80 (*above*) First stage **Fig. 81** (*below*) Second stage

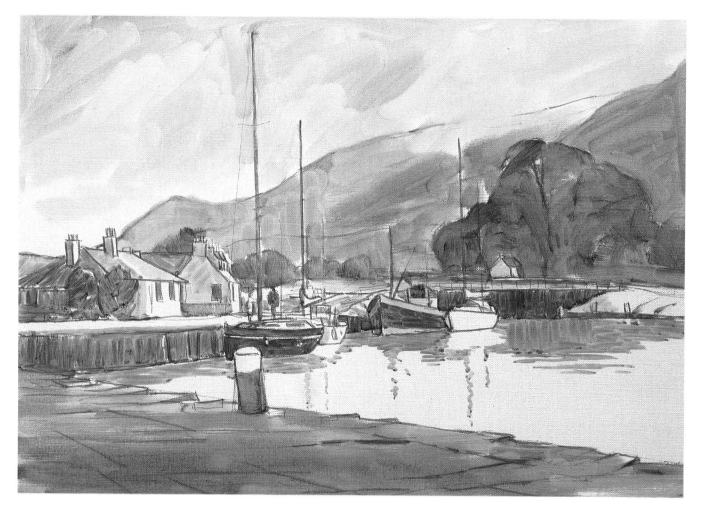

Fig. 82 Detail from finished stage

Titanium White. Use Titanium White and Yellow Ochre for the sunlit walls and add a little Cobalt Blue and Crimson Alizarin for the walls in shadow. With this colour still on the brush, drag it across the buildings underneath the gutters to show a shadow. Now with a dark colour, using downwards brush strokes, paint in the solid fence in front of the furthest house. Next, paint in the two small trees in front of the first house, using your tree colour.

Next work the boats. Use Cobalt Blue, Crimson Alizarin, Yellow Ochre and just a touch of Titanium White for the dark boats; use Cadmium Red and Crimson Alizarin for the red line on the nearest boat and the sail on the white boat. For the white super-structure and white boat use Titanium White, Cobalt Blue, Crimson Alizarin and a touch of Yellow Ochre. Paint these boats with your Series B48 No. 1 brush, but don't go for detail. All you want at this stage is the form of the boats. Now paint in the quay in front of the houses, using Titanium White, Yellow Ochre and Crimson Alizarin for the top half and adding Cobalt Blue and less Titanium White for the bottom half. Finally, paint in the masts, using your Rigger No. 1.

Finished stage Now the water. Use your Series B48 No. 2 brush and paint in the dark reflection, using Cobalt Blue, Crimson Alizarin, and Yellow Ochre, adding a little 'tree colour' where the reflection is under the large trees. Then, with plenty of Titanium White mixed with Cobalt Blue and Crimson Alizarin, paint the 'blue' water and work it back into the dark reflection to show water movement. With a mix of Titanium White, Cadmium Yellow and Crimson Alizarin, work from the light blue to the harbour wall, getting lighter as you get to the edge of the wall. Then work some of this colour back into the blue with horizontal, broken brush strokes to represent water movement. Now, using your Series B48 No. 4 brush, paint in the foreground, using Yellow Ochre, Crimson Alizarin, Cobalt Blue and a little Titanium White. Then paint the black and white post.

To finish the picture you have to put in the detail, or the illusion of detail. Suggest the figures on the quayside using your Series 43 No. 4 sable; paint in the 'white' of the white yacht with your No. 4 sable, using Titanium White and Cadmium Yellow. With your Rigger No. 1, paint in the railings over the lock gates; with the same brush, paint in the rigging lines on the boats and then the lines on the quayside to represent the stone edges. With your Series 43 No. 4 sable, paint in the shadow of the post and, finally, using your Rigger No. 1 with Titanium White and Cadmium Yellow mixed, paint in the seagulls over the fishing boat. Be delicate with your brush strokes and imagine that the brush is 'flying'. This will give the seagulls feeling and movement.

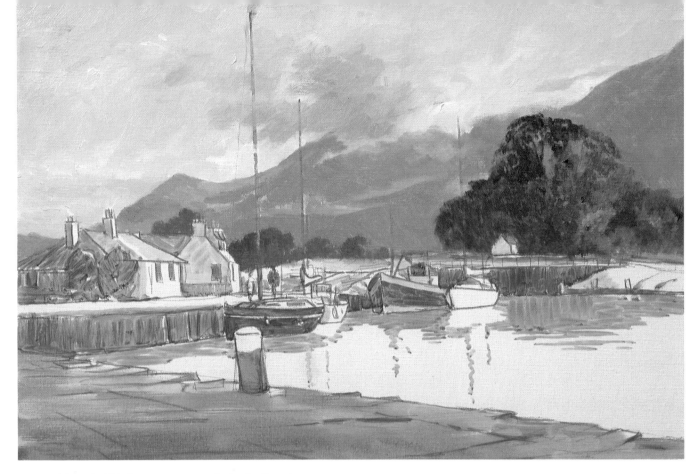

Fig. 83 (*above*) Third stage **Fig. 84** (*below*) Fourth stage

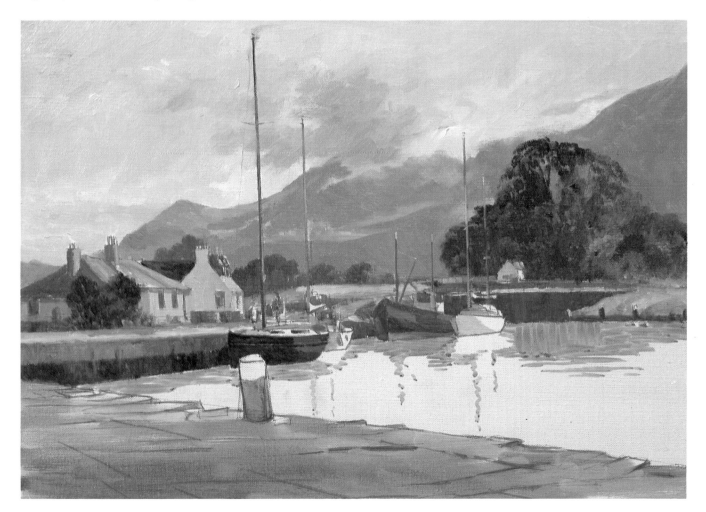

Now have a coffee and come back to *your* painting with a fresh eye and add or subtract anything that you feel will help it. I hope you are pleased with your painting of the boats and that you enjoyed it – I did.

I am sure that now you have completed all three exercises you will be feeling very pleased with yourself – brimming over with confidence and waiting to show your pictures to the next person who comes to your home. Well, this is the way it should be. It is far better to create a picture for other people to enjoy than just for yourself. You are sharing your pleasure with others. However, while it is easy to accept admiration, do be prepared to respect criticism. Do not let it deflate you or your hard-earned confidence, but accept it in the spirit it is given and you will probably learn something to help you in your next picture. Whatever your standard of ability, do not be afraid to show your paintings. The all-important factor is that, from a white, blank canvas, you have created a picture – be proud of it, continue to paint and, above all, enjoy your painting.

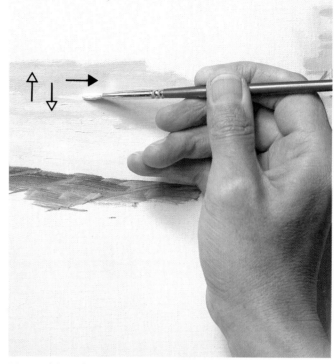

Fig. 85 (*above*)

Fig. 86 (*below*) Watercolour painted on location used for reference

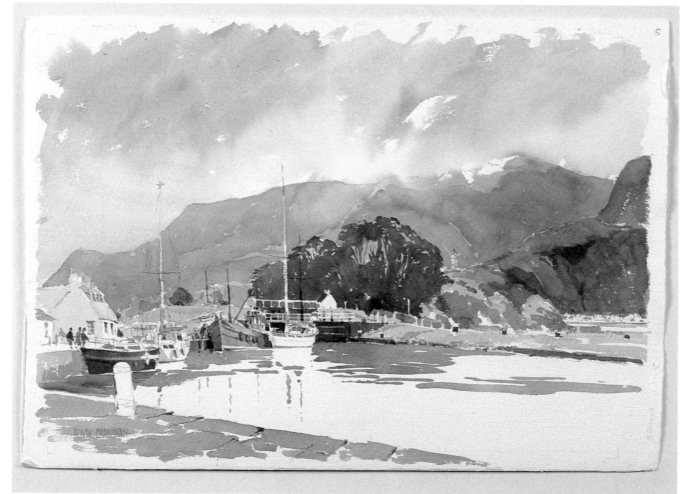

Fig. 87 (*above*) Finished stage, 30×41 cm (12×16 in) **Fig. 88** (*below*) Detail from finished stage

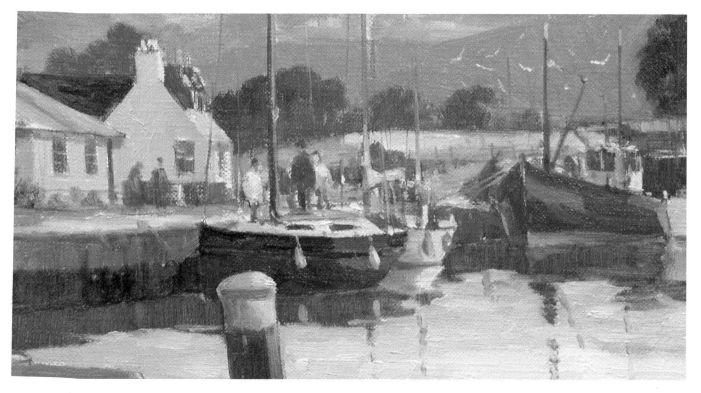

VARNISHING

Now that you have progressed through the book, you should have quite a few exercises and paintings all finished and taking pride of place on various walls throughout your home or, dare I say it, friends' homes. And we haven't yet talked about varnishing the paintings. The reason for varnishing is (a) it protects the pigment from atmospheric impurities that could discolour your painting, and (b) varnish will restore colours to their original brilliance. You will have noticed by now that on some parts of the paintings the colours have gone greyer or dull, and other parts are shiny. This is the way paintings dry but varnish will bring them back to their original colours. However, a painting should not be varnished for at least six to nine months after it has been painted as, during this time, considerable changes are occurring within the paint film structure and the application of varnish would inhibit some of these changes. This, in turn, could have an adverse effect on the oil painting in the long term.

If you want to exhibit a painting, or you want it to look its best before it is time to varnish, you can use a Re-touching Varnish as a temporary measure, varnishing straight on top of your paint. This can be bought from your local art supplier as can the normal varnish. With the normal varnish, however, you need to 'wash' your picture in the following way before varnishing. Clean the surface of the picture with a piece of cotton wool dipped into soapy water and squeezed out (you do not want to 'soak' your painting). This is to clean off any grease and dirt that has accumulated over the past months. Then, with clean water, wipe over again to get rid of any traces of soap. Finally, dry the painting with cotton wool and make sure you don't leave any fibres of cotton wool on the surface. When it is absolutely dry, you can varnish it. I use Artists' Clear Picture Varnish. Use the varnish brush illustrated on page 11 (**fig. 11**). Start at the top of the painting and work down and across, brushing the varnish in well. You must do the whole painting in one operation. If you only varnished part of the painting and the varnish started to dry, when you came back to finish it you would get a thick edge where the two varnishes joined up. You must also do your varnishing in a room where there is as little dust as possible.